IMAGES
of America

SHEPHERDSTOWN

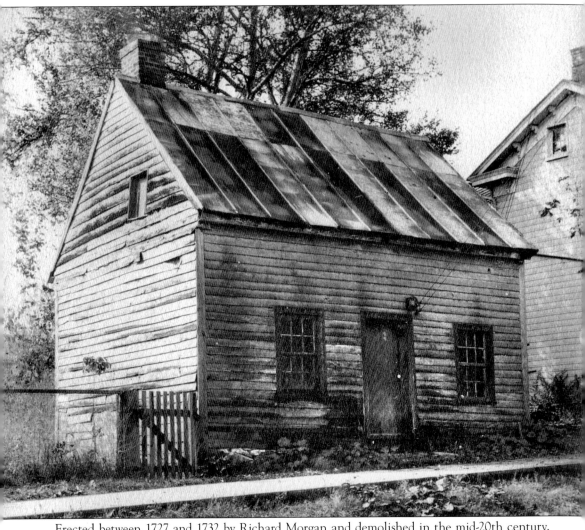

Erected between 1727 and 1732 by Richard Morgan and demolished in the mid-20th century, this was the oldest house in West Virginia according to some sources. For years, it served as the home of Miss Texie Lucas. The house was located in Shepherdstown on the first block of East High Street, just across from the entrance to Shepherd's Mill. (Courtesy of Jefferson Security Bank, Shepherdstown.)

IMAGES
of America

SHEPHERDSTOWN

Dolly Nasby

Published by Arcadia Publishing
Charleston SC, Chicago IL, Portsmouth NH, San Francisco CA

Printed in Great Britain

Library of Congress Catalog Card Number: 2005927106

For all general information contact Arcadia Publishing at:
Telephone 843-853-2070
Fax 843-853-0044
E-mail sales@arcadiapublishing.com
For customer service and orders:
Toll-Free 1-888-313-2665

Visit us on the internet at http://www.arcadiapublishing.com

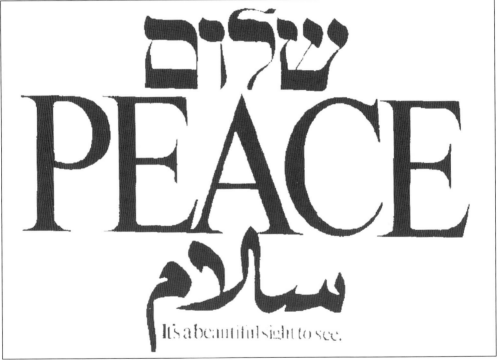

This sign, featuring Hebrew, English, and Arabic, says, "Shalom, Peace, Salaam, It's a beautiful site to see." It hung in Hali Taylor's mother's kitchen in La Jolla, California, for 22 years. Upon her mother's death in 1989, Hali brought the yellowed and brittle peace sign to Shepherdstown, where it became very popular during the peace talks of 2000. Her mother had cut out a full-page message in the *Los Angeles Times* in 1967, after the Six Day War in the Middle East. When the peace talks came to Shepherdstown, Hali, the assistant director of the library, hung the sign in the library window, and the idea took off from there. Before long, the sign could be seen in every building, window, door, house, business, and even in car windows. That tradition has continued, as the sign is posted in many windows and doorways in this quaint town today.

CONTENTS

Acknowledgments 6

Introduction 7

1. The Town 9

2. Day by Day 45

3. Education 73

4. Transportation 87

5. Fashion 107

6. Shepherdstown Today 125

ACKNOWLEDGMENTS

Where do I begin to thank everyone who has helped me in this endeavor? I guess first would be to thank Arcadia for giving me a contract to create this pictorial history. Thanks also go to the Jefferson County Museum in Charles Town, because they were gracious enough to share their photographs. Jim Surkamp, one of our Jefferson County commissioners, deserves a huge thank you for sharing his photograph collection. Another person who was very helpful was Margie Redding Bostone, who helped me identify many of her family members in photographs. Thanks also to a former resident of Shepherdstown, Ruth Shipley Roth, for sharing her family photographs and history. While I did not meet Mr. Richard Clark, he did grant me permission to use many of his family photos, and I thank him for that. A special thanks goes to Mark Goodrich of Jefferson Security Bank for sharing the bank's photograph collection. Shepherd University library was very generous with their collection and I thank them. And of course, the bakery on the corner by the library sells some of the most delicious brownies so I was able to keep my energy level high enough to complete this book.

I know that this book on Shepherdstown is far from a complete work. It is simply a pictorial history, compiled using the photos that were available to me. If you are interested in seeing my sources for the text, please visit the little library in Shepherdstown and find the following: *An Illustrated Walking Tour of Shepherd's Town* by Judith Weaver; *A History of Shepherd College* by Arthur Bordon Slonaker, M.A.; *Shepherdstown, An America Treasure* by Martin R. Conway; *See Shepherd's Town* by the Bicentennial Commission 1976; and *Between the Shenandoah and the Potomac* by the Jefferson County Historical Society. If this book contains misinformation, please contact Arcadia Publishing, who will forward all messages to me.

Of course, I thank my hubby of 42 years for letting me delve into my hobbies to such an extent that they literally take over all of my spare time. And last of all, but by no means least of all, I thank my children, and it is to them that I dedicate this book. My three wonderful children have inspired me to be a better person, to be all that I can be, and to achieve my goals. They have made me realize what a precious commodity life is, and how wonderfully happy and content children can make you feel. Thank you, Michael, Diane, and Melissa, for being such wonderful children. I could not have asked for better or more loving children. I thank God for blessing me with you, and I was honored to be your mother. I apologize for any of my shortcomings, and I will love you always, deeply.

INTRODUCTION

Everyone has stories of what their parents *almost* named them. I was going to be called "Sadie Ophelia" after my two grandmothers, but my parents chose Dolly instead, for which I have always been grateful. Shepherdstown is much the same. Some of the names she was given, unofficially, include Old Unterrified, Swearingen's Ferry, Mecklenburg, Shepherd's Town, and Tom Shepherd's Town. One of the town's claims to fame is that it is the oldest town in the state. In fact, it has not had a boundary change since 1798.

In the early days, getting across the Potomac River would have been impossible had it not been for Pack Horse Ford. Due to the ford's location, the growth of this little town was guaranteed. The town's first bridge was a covered bridge constructed in 1849 and destroyed by Union troops in August 1861.

Shepherdstown's architecture makes it unique; there are many well-preserved buildings of Georgian, Victorian, Federal, Greek Revival, and Art Nouveau styles. Residents think of Shepherdstown as an American treasure.

In the beginning, it was just a place on the Potomac where both people and animals could cross the river. Pack Horse Ford had other names as well: Boteler's Ford, Blacksford Crossing, and Shepherdstown Ford. Less than a mile upstream from the ford, Thomas Shepherd obtained a land grant of 222 acres on Falling Spring in 1734. The power from this water attracted settlers, and the town began. Between 1734 and 1739, Shepherd built a gristmill and later added a second one. He also built a stone fort on Lot 36 for protection from the Native Americans, but that fort would be dismantled in 1812. Shepherd had laid out the town on both sides of the spring by 1752, with streets and alleys. Shepherd designed the town on 50 acres of his own land. He divided it into 96 lots with eight streets and offered settlers very attractive terms.

Shepherd wanted to honor his queen, wife of England's George III, by naming the town for her. However, the name had already been assigned to a town farther south in Virginia. Therefore he chose Mecklenburg, which was the name of the German state on the Baltic Sea from which Queen Charlotte hailed, and the Virginia General Assembly granted a charter on December 23, 1762, thereby making it the oldest town in West Virginia. It was not until 1820 that it was chartered as Shepherdstown.

The mill that Shepherd built on High Street served the town for more than 200 years. It has a preserved 40-foot water wheel that is reputed to be the largest in the world. It was powered by the Town Run.

In 1756, Thomas Swearingham established a ferry across the river. Interestingly enough, he had defeated George Washington in the election for burgess of Frederick County, Virginia, but the tables turned the next year, and Washington defeated Swearingham. And of course, Washington went on to even greater things.

In November 1766, the General Assembly of Virginia established two annual fairs for the town— one in June and one in October, for two days each—and the fairs continued until 1800. Other fairs in the area were discontinued in 1931 because of hardship during the Great Depression.

In 1776, volunteers were recruited by the Continental Congress; 96 Shepherdstown men replied. Their march became known as the "Beeline to Boston" and took 26 days to cover 600 miles. The men of Shepherdstown fought along side Washington at Valley Forge. In military engagements, volunteers from Shepherdstown rose to the occasion time and time again—during

the Revolutionary War, the War of 1812, the Civil War, the Mexican War, World War I, World War II, the Korean Conflict, and Vietnam.

A very important name in the history of this town is James Rumsey. In September 1786, George Washington encouraged him to build a steamboat. Rumsey demonstrated his 48-foot steamboat on the Potomac River on December 23, 1786, at a speed of three knots, traveling all of a quarter of a mile upstream, having launched his boat at the site of the original ferry landing on Princess Street.

In 1790, West Virginia's first newspaper, *The Potowmack Guardian*, was published by Nathaniel Wills. Three years later, in 1793, the first post office in West Virginia was established at Shepherdstown.

In the early 19th century, George Weiss made reddish-brown crocks and other containers in the old German artisan style, and they became well known as Shepherdstown wares. By 1821, the town's first fire company was formed.

Notable military leader John F. Hamtramck was a graduate of West Point in 1819, and he served in the army until 1831. He returned to active duty for the Mexican War in 1846. The Hamtramck Guards, named in honor of John, participated in the capture of John Brown in Harpers Ferry in 1859. In 1861, when Virginia seceded from the Union, the Hamtramck Guards was one of the first units to join the Confederate Army. It became Company B, 2nd Virginia Infantry of the famous Stonewall Brigade. During the Civil War, there was a battle in Shepherdstown, but the town was spared. In 1863, all town taxes were required to be paid in Confederate money, an indication of the citizens' loyalty.

The Battle of Antietam caused the town to be inundated with 3,000 wounded men, and the town rose to the occasion and cared for them in September 1862. In this same month, the Battle of Shepherdstown took place.

During the last year of the war, wanton destruction of some lovely homes occurred in Shepherdstown. The county seat had been in Charles Town, but during the war, it was moved to Shepherdstown; it was not until 1871 that the seat was returned to Charles Town. In 1872, Shepherd College was established.

In 1859, Rezin Shepherd, grandson of the town founder, began construction of the old courthouse, which was to be used as a town hall. It served as a hospital after the Battle of Antietam during the Civil War, as a county courthouse, and as a hall for Shepherd College starting in 1873. It was later named McMurran Hall after the college's first president.

The railroad arrived in 1880. In 1883, the town participated in the Temperance Parade in June. The town lamplighter was employed by the town and received an annual salary of $65 for cleaning and repairing the town's 25 street lights.

Tramps were not allowed within the town limits in 1896. The first telephones in the county were installed in the office of *The Shepherdstown Register* (the local newspaper) and at the Entler Hotel in 1898.

Women were given the right to vote in 1921. A year later, the women's club established a library in the old market house.

In 1973, the National Park Service of the Department of the Interior named Shepherdstown a Historic District on the National Register of Historic Places, thereby guaranteeing Shepherdstown a future.

Today Shepherdstown sits as a beacon of light to surrounding communities. Shepherd University ensures that the town will thrive as a college town, and the residents guarantee that it will remain a picturesque little town dedicated to preserving its own history. Often referred to as "Georgetown West," it continues to attract visitors from all walks of life to the quaint little shops that line German Street. Townspeople continue to love their little town and keep its pristine streets free of anything that would detract from the sophisticated atmosphere that permeates the town.

I hope you enjoy this perusal of Shepherdstown. It is by no means a complete history of the town and its people—only a quick glimpse at a town filled with wonderful stories and families, a town to which this little book cannot do justice.

One

THE TOWN

The story of Shepherdstown began when Thomas Shepherd established a gristmill on the Town Run. Others followed and took advantage of the same water power, establishing businesses and factories. Thus industries and a town were born.

Growth was natural, especially since Shepherdstown was located on an important river, the Potomac. Since it was so close to Antietam and Harpers Ferry, it became a hot bed of activity during the Civil War. Its close proximity to Charles Town meant that important Washington family members, as well as other political leaders, would make visits to the town.

The college (later, university) helped the town become both a cultural and an intellectual center, which it remains today. The university's location in town has helped businesses arise and thrive.

The people of Shepherdstown have exhibited a remarkable sense of the historical importance of the town and have maintained its quaint appearance. Buildings along the main street, today called West German Street, look very much as they did 100 years ago.

The town seems to have found its niche in society. The residents like the town the way it is and strive to keep it from becoming overgrown. They do not oppose change but also do not embrace it for change's sake. For example, stop signs have been sufficient at many intersections for many years instead of stop lights. Residents and visitors alike continue to enjoy the laid-back attitude and atmosphere of a town caught in a time warp with no aspirations to modernize any more than necessary.

One of the oldest houses in West Virginia, the "Old Stone House" at Morgan's Spring, was built in 1740 by Richard Morgan. Morgan came from Wales and got the property by a regal grant from Lieutenant Governor Gooch in 1734. It was near here that Morgan raised a company of troops to protect local residents and to participate in the French and Indian War. It was not until 1904 that the property passed out of the hands of the Morgan family. (Courtesy of Jim Surkamp, Shepherdstown.)

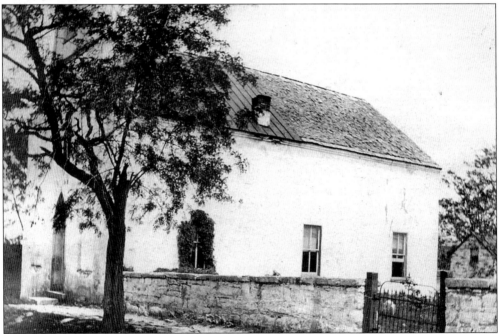

This photograph shows the church and graveyard of the First Episcopal Church, dating from the mid-18th century. The church was located on the southeast corner of High and Church Streets. In c. 1870, it became the Black Methodist Church. (Courtesy of Jim Surkamp, Shepherdstown.)

Located near Shepherdstown is Aspen Pool, built on a tract of land that was acquired from Lord Fairfax by Thomas Shepherd in 1751. His son, William, inherited 104 acres and later deeded that in 1788 to William Morgan. It is speculated that Morgan was the builder of the house. The house is large for the time with four levels—a full basement, two stories, and an attic. (Courtesy of Jim Surkamp, Shepherdstown.)

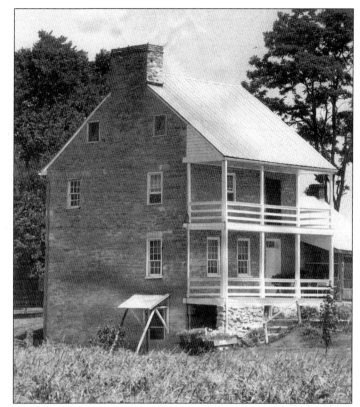

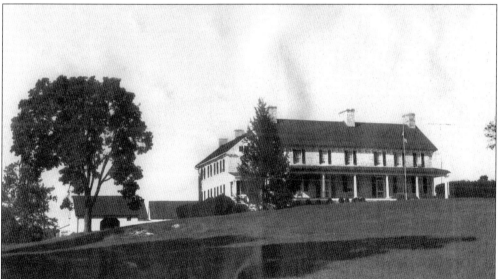

The main portion of Springwood was built by Colonel Van Swearingen in 1759 on land granted by patent in 1734 to three gentlemen. Once known as Rocky Fountain, it was sold to Abraham Shepherd by the heirs of the colonel. Two stone outbuildings were added in 1819, and in 1822, his son, Henry Shepherd, added a two-story wing. In 1907 and 1910, the house changed hands again. The mansion has 15 rooms and is well preserved. Some sources say the walls are three feet thick in some places. (Courtesy of Jefferson County Museum, Charles Town.)

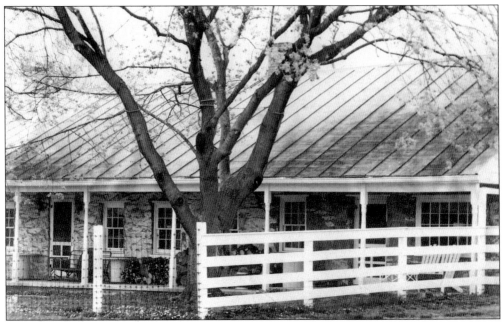

Gen. William Darke owned a sizeable estate during the Pre-Revolutionary times. Pictured here are the servants' quarters on the estate grounds. General Darke had a very eventful military career with action in 1758–1759 against Native Americans and during the Revolutionary War, after which he was made a lieutenant colonel. Later he became brigadier general after fighting Native Americans in Ohio in 1791. (Courtesy of Jim Surkamp, Shepherdstown.)

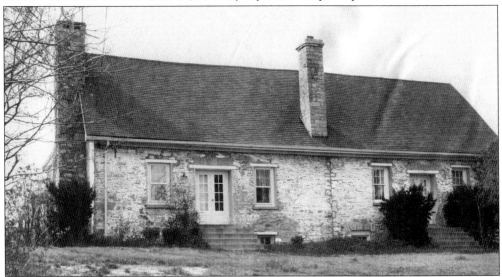

Prato Rio was unique because the owner, Charles Lee, divided the interior not by partitions (walls) but by chalk lines on the floor, thereby allowing for "flowing space." This concept of flowing space was something that the Native Americans did in their lodges. For a time during the Revolution, he was second only to Washington himself. However, he fell into disfavor, was court-martialed, and was suspended by Congress for a year for "disrespect" and "disobedience." Prato Rio was left to his two Italian servants upon his death in 1782. (Courtesy of Jefferson County Museum, Charles Town.)

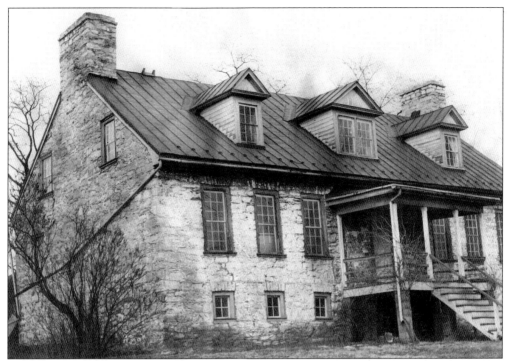

Gen. Horatio Gates moved to Traveler's Rest in 1773. Located near Kearneysville, Traveler's Rest was built to last with limestone walls! General Gates settled in the Shenandoah Valley as did Charles Lee, his colleague. Gates served in the Revolution as the adjutant general for Washington. He was one of the distinguished citizens who watched James Rumsey's steamboat on the Potomac in 1787. (Courtesy of Jefferson County Museum, Charles Town.)

This is the home of James Rumsey, who was the inventor of the steamboat. Witnessing the trial of the steamboat on the Potomac River, Gen. Horatio Gates is said to have tipped his hat and shouted, "By God! She moves!" The boat traveled for two hours at three miles per hour, going up and down the river for all the distinguished citizens of Shepherdstown to see. (Courtesy of Jefferson County Museum, Charles Town.)

Here sits Belle Vue, a large home that was constructed on Shepherd Grade at the edge of Shepherdstown. The original builder was Capt. Joseph Van Swearingen, who was an officer in the Revolutionary Army. He later was appointed by Gov. James Monroe to become one of the first justices of the peace in Jefferson County when it was formed in 1801. (Courtesy of Jefferson County Security Bank, Shepherdstown.)

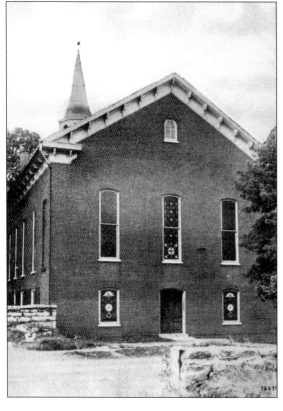

Pictured here is the side of the Christ Reformed Church on the south side of German Street. The oldest part of this church dates from the 18th century. One of the bells in the bell tower was transported from Europe by Michael Yeasley. The bell was used to hold wine during the church's first communion service. (Courtesy of Jim Surkamp, Shepherdstown.)

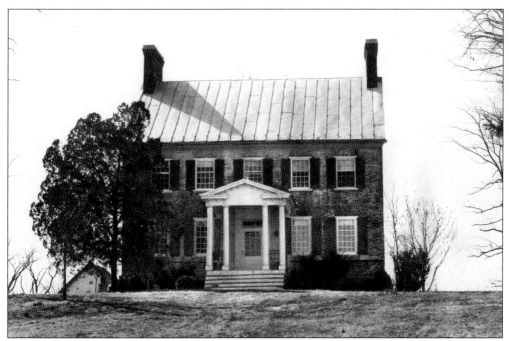

Built in 1787 and located two miles south of Shepherdstown is Elmwood, a two-story brick home with four wide rooms on each floor, in addition to a basement. The Lucas family owned the 200 acres on which it sits for more than 200 years. Robert Lucas was a Quaker who came to America in 1679. Edward Lucas III, Robert's grandson, received a land grant from Lord Fairfax in 1732, and it is on that grant that Elmwood sits. (Courtesy of Jim Surkamp, Shepherdstown.)

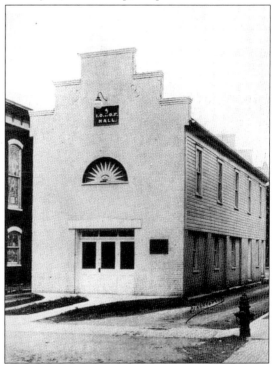

Constructed in either 1800 or 1801 (depending on the source), this little building has served the community of Shepherdstown in many capacities. First it was used as a market house. In 1845, a second story was added by the International Order of the Odd Fellows (IOOF) to be used as a meeting room. The downstairs was converted into a fire hall in 1853, and in 1888, a bell tower was added, although that was later removed. Other uses included the following: town hall, council meeting place, courthouse, jail, and school. The woman's club began using the lower portion as a library in 1922. Eventually both stories were included for library use. (Courtesy of Jim Surkamp, Shepherdstown.)

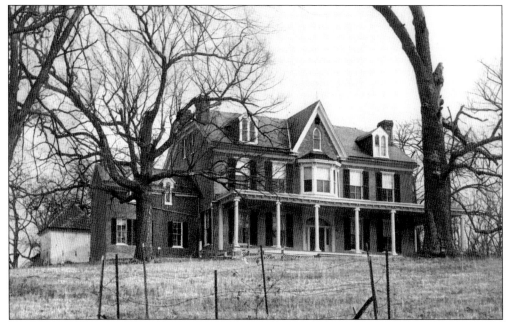

The Bower saw singing and dancing every night, with guitars and banjos, when the glamorous general of the Confederate cavalry, J. E. B. Stuart, used this brick house as his headquarters. Stuart made a famous raid in Pennsylvania, returning with 1,200 horses and $250,000 worth of supplies. In addition, he brought hostages with him to be exchanged later. Built in 1805, the estate has been owned by the Dandridge family. (Courtesy of Jefferson County Museum, Charles Town.)

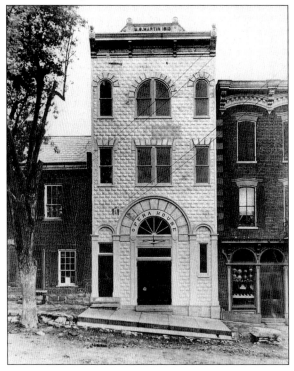

This is an early photograph of Upton S. Martin's Opera House. It was located on German Street in Shepherdstown, and the date on the top of the building is 1810. Originally the moving pictures that were shown in this opera house captivated the audience for all of 5¢ per person. The opera house boasted several "firsts"—a continuous show, a ventilating system, a pipe organ, and reserved seating. In addition, when talkies came out, Shepherdstown was the smallest town in the whole country to enjoy sound in its theater. (Courtesy of Jefferson Security Bank, Shepherdstown.)

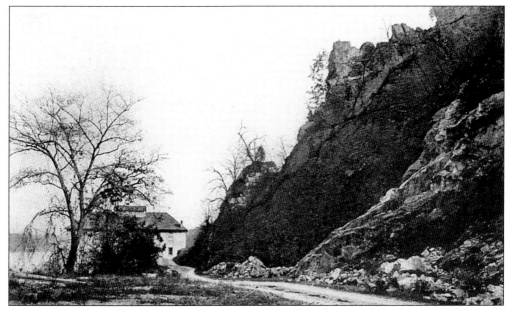

Around 1830, this mill was converted to a cement mill. It had originally been a flour mill owned by George Reynolds and Henry Boteler. As a cement mill, it operated until 1889, when extensive damage was caused by a flood. In 1900, the mill ceased all operation, and in 1919, the bricks were used to construct a large garage and storage building on the northwest corner of Princess and Washington Streets in Shepherdstown. (Courtesy of Jefferson Security Bank, Shepherdstown.)

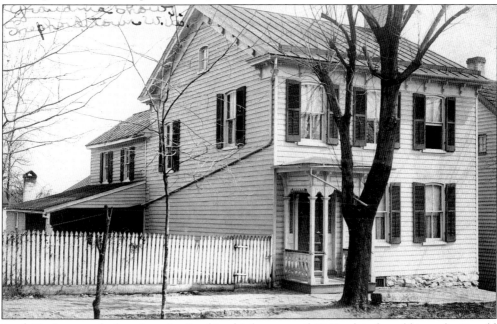

Jacob Kraft was a clock maker who lived in this house until 1840, when he sold it to the Unseld family. Eventually the property was willed to Elizabeth Catherine Cookus, and the Cookus family held title for many years. It was located on German Street. After the Cookus family, the Show family was the owner. Eventually it was sold out of the Show family in 1997. (Courtesy of Margie Redding Blostine, Shepherdstown.)

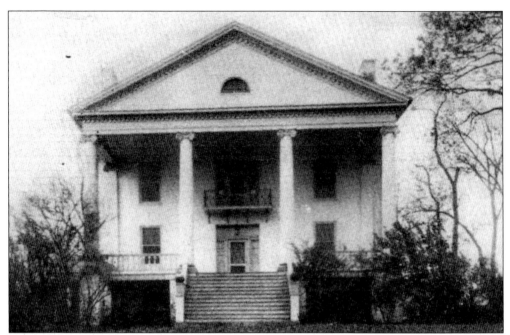

Falling Spring was built in 1841 by Jacob Morgan, one of the earliest settlers in the area. In 1740, his grandfather, Richard Morgan, built a stone house not too far from the future site of Falling Spring. The house was built of brick and then covered in a smooth stucco. The entrance on the west side of the house was used as the front door. Later, a portico over the driveway was added. Col. William Morgan, the second owner, was a prominent Confederate officer. (Courtesy of Jefferson County Museum, Charles Town.)

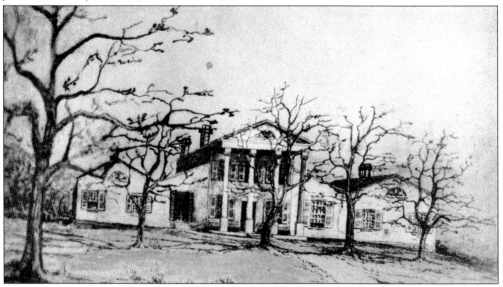

Violet Dandridge drew this rendition of Bedford, the family home of Edmund Jennings Lee and his wife, Henrietta Bedinger Lee. It was located on high ground on the west side of Flowing Springs Road and faced south. Bedford was destroyed by Union general David Hunter in 1864. Nettie Lee, daughter of the owners, described Bedford to Violet Dandridge, who drew it from that description. (Courtesy of Jim Surkamp, Shepherdstown.)

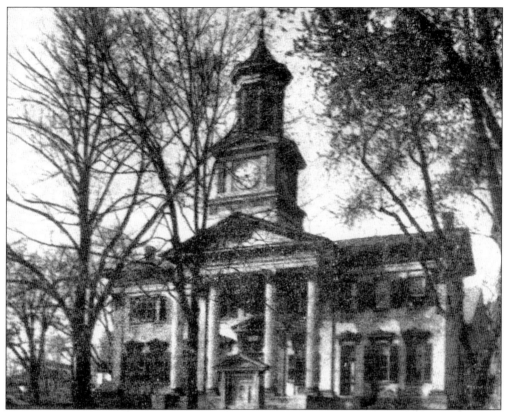

The name of the old college and courthouse was later changed to McMurran Hall to honor Dr. Joseph McMurran. Dr. McMurran first headed Shepherd College, which was founded as a classical and scientific institute in 1871. Erected on the site of Thomas Shepherd's original stone house, the main portion of the building dates to 1859. (Courtesy of Jefferson County Museum, Charles Town.)

Looking northeast from the southwest corner of German and Mill Streets, the Parran House is pictured. In October 1862, J. E. B. Stuart visited this house, which was occupied by widow Lily Parran Lee. From Mrs. Lee, Stuart got back a pair of silver spurs that had been worn by her husband, and Stuart's friend, Col. William F. Lee, who was killed at Manassas. When Stuart visited the house, the local girls clipped souvenir locks of his hair. (Courtesy of Jim Surkamp, Shepherdstown.)

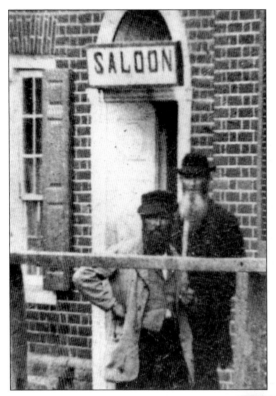

Two men pose outside a saloon around February 1865. Joseph Chapline's Store was undergoing a store opening celebration, and these men were in attendance. Chapline's Store was located next to the future Betty's Restaurant. The store sold a variety of goods and was referred as a general store, because it carried a wide selection of general merchandise. (Courtesy of Jim Surkamp, Shepherdstown.)

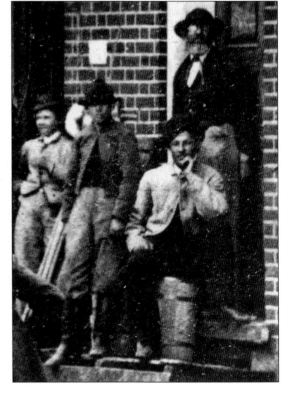

This early-1865 photograph shows attendees at the opening of the store owned by Joseph Chapline. The store was located on German Street, due west of what would later become a landmark business in Shepherdstown, Betty's Restaurant. (Courtesy of Jim Surkamp, Shepherdstown.)

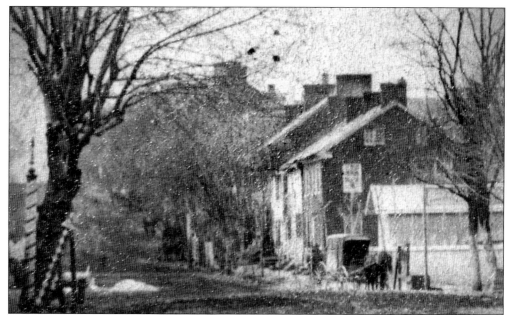

Taken about 1865, this photograph looks west on German Street and shows Lot No. 1 of the town's original plat. A two-story building sits on the lot in this photograph, behind the wagon. It was in this house that Jacob Sheetz made Kentucky long rifles for a company of soldiers that marched from Shepherdstown to Boston during July and August 1775 to join the Continental Army. (Courtesy of Jim Surkamp, Shepherdstown.)

As the story goes, in 1883, a large number of bovines were allowed to roam the town streets and pasture therein. However, young trees were being destroyed by the hungry cows. In addition, on a fine Sunday morning, the town residents were dismayed to find many "surprises" left by the animals. Therefore, the problem was handled by the town council, when it ruled that cows were no longer allowed to roam the streets. (Courtesy of Jim Surkamp, Shepherdstown.)

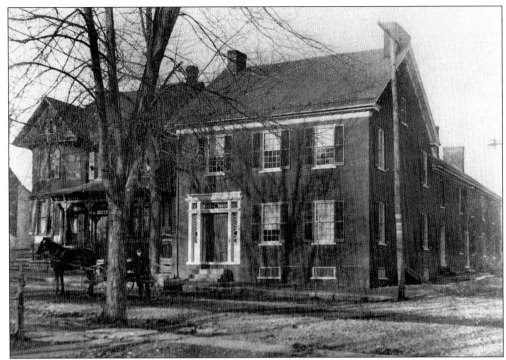

In the early 20th century, this Federal-period house served as the Shepherdstown Presbyterian manse. It is located on the northwest corner of Church and German Streets. This photograph dates to "horse-and-buggy days." (Courtesy of Jefferson Security Bank, Shepherdstown.)

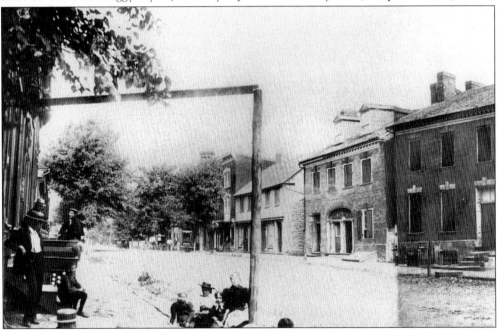

This view is of the north side of German Street. The Entler Hotel is visible. In the early 20th century, the buildings located to the left of the Entler Hotel were destroyed by fire. (Courtesy of Jefferson Security Bank, Shepherdstown.)

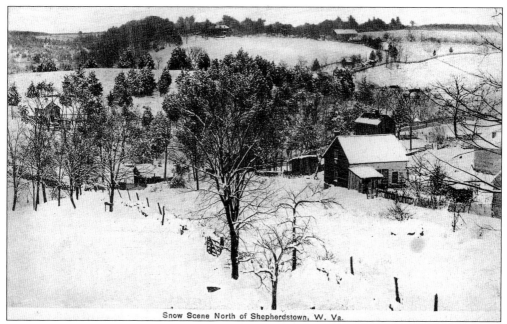

Snow Scene North of Shepherdstown, W. Va.

Shepherdstown in winter is pictured here. What a lovely scene of freshly fallen snow. In the distance, Bridgeport and Ferry Hill are visible. This view is looking toward the Potomac River. (Courtesy of Jefferson Security Bank, Shepherdstown.)

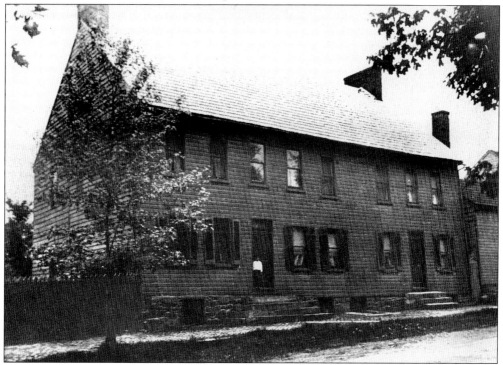

Here sits Joseph Entler's Great Western Hotel. It was located on West German Street. In the 1930s, it was renovated, and that renovation greatly changed its exterior appearance. (Courtesy of Jefferson Security Bank, Shepherdstown.)

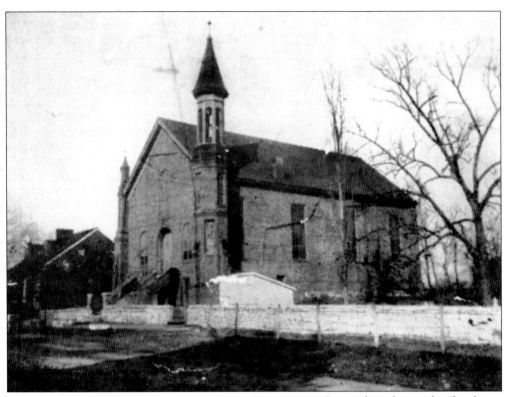

Located on the north side of German Street was the old St. Peter's Lutheran Church, pictured here. It was located just east of the Norfolk Southern Railroad. The congregation built a new church in the early 20th century. (Courtesy of Jefferson Security Bank, Shepherdstown.)

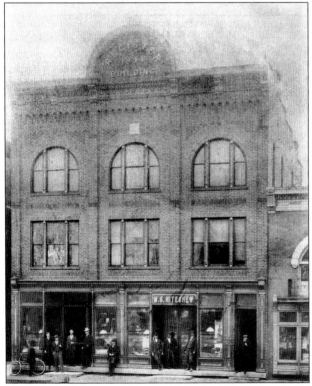

M. S. Hiteshew was a dealer in both foreign and domestic wares. His shop, built in 1894 by H. L. Snyder, is located in the Register Building in Shepherdstown. Of the nine gentlemen standing in the doorway, eight are wearing hats, and all are wearing suits. The person on the bicycle did not have to worry about the price of gas. (Courtesy of Jefferson Security Bank, Shepherdstown.)

Taken in the late 1890s or early in the first decade of the 20th century, this photograph shows the ruins of White Henkle Woolen Mill, which dated to the 1850s and was located along the Town Run. Many of the mills and tanneries in Shepherdstown were located along the Town Run for energy. In the background on the left is the 40-foot-diameter wheel, which was later moved up to Shepherd Mill. (Courtesy of Jim Surkamp, Shepherdstown.)

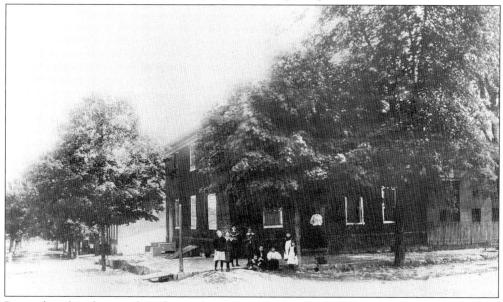

Pictured in this photograph is the northeast corner of Princess and German Streets, which would later be the home of the Yellow Brick Bank. (Courtesy of Jefferson Security Bank, Shepherdstown.)

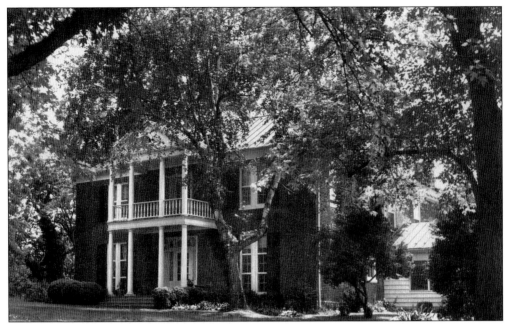

Rose Brake, once known as Poplar Grove, has had many owners. Of those many owners, only two families have held ownership for more than 90 years—first the Morgans, and then the Bedingers for more than 100 years. One Bedinger, Caroline Dane Bedinger, was born in Denmark and was called "Danske," which means "the little Dane." She went on to become a well-known historian and poet. Eventually, Rose Brake was sold to people outside the Bedinger family. (Courtesy of Jefferson County Museum, Charles Town.)

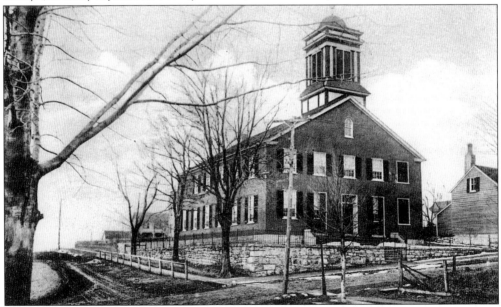

Pictured here is the Presbyterian church on the southwest corner of King and Washington Streets. The photograph was taken around 1900. Prior to having an established church structure with a pastor, a circuit preacher would visit to attend to the needs of parishioners. (Courtesy of Jim Surkamp, Shepherdstown.)

St. Peter's Lutheran Church, established in 1765, served its congregation until 1775 in a log church. The cornerstone of its later building was laid August 30, 1795. It was later remodeled in 1868. This photograph was taken at the dedication of new St. Peter's Lutheran Church in Shepherdstown, August 9, 1908. The church is located on the west side of North King Street, between High and German Streets. Gladys Hartzell wrote the history of the church in her book entitled, *On This Rock: The Story of St. Peter's Church*, published in 1970. (Courtesy of Jim Surkamp, Shepherdstown.)

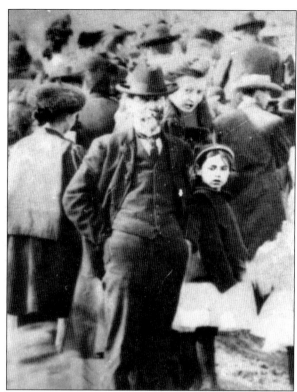

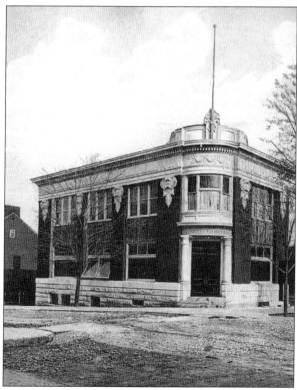

In 1906, this building was constructed and named Jefferson Savings Bank. Three years later in 1909, the name was changed to Jefferson Security Bank. The building is located on North Princess and East German Streets. The architectural style of the building is Beaux-Arts. It became known as the Yellow Brick Bank and later served as a restaurant and an inn. Despite its name, only the building's trim is painted yellow. (Courtesy of Jefferson Security Bank, Shepherdstown.)

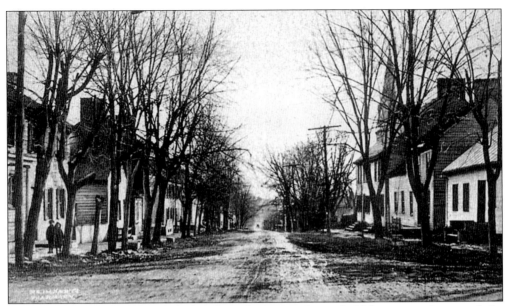

The spire of the Trinity Episcopal Church can be seen in this early-20th-century photograph. Its view is partially blocked by the buildings on the right. Of those buildings, the home of the Byers Family is the farthest to the right, at the extreme right edge of the photo. The second house was the home of teacher Ella Kelsey in the 1920s. In the 18th century, Joseph Entler's Great Western Hotel was situated next, not to be confused with the current Entler Hotel. (Courtesy of Jim Surkamp, Shepherdstown.)

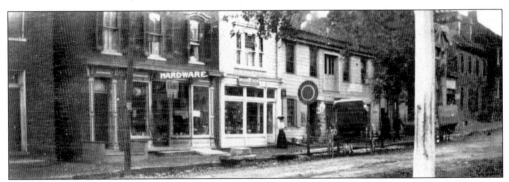

This photograph of this hardware store was taken in 1908, looking from the south side of German Street toward the future Four Seasons Books. This store was known as H. C. "Tug" Marten's Great Cheap Hardware Store. It was here that Tug Marten made and sold his own cast-iron stoves, which were stamped to identify them as his. They were sold throughout the area. (Courtesy of Jim Surkamp, Shepherdstown.)

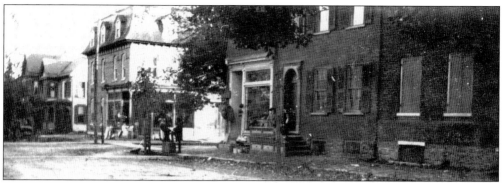

Hodge's-Lemen Feed Store was located in the building pictured here (center) in this 1908 photograph showing the south side of German Street. Princess Street runs perpendicular to German Street between this building and the lighter-colored building on the left. The latter was built and owned in the 1890s by Matt and Hattie Tolliver, who were African Americans. They owned the building and ran an ice-cream emporium, a restaurant, and a livery service. A bowl of ice cream sold for a nickel. (Courtesy of Jim Surkamp, Shepherdstown.)

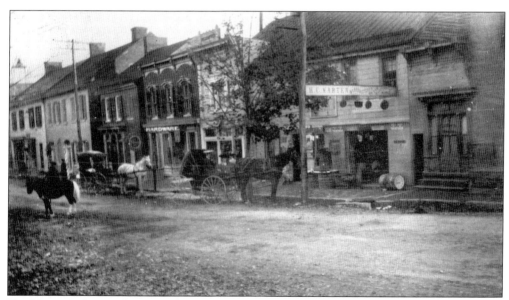

Tug Marten's Great Cheap Hardware Store is shown in this 1908 photograph from a different vantage point. The photographer is looking east toward the south side of German Street. To the extreme left, a person can be seen sitting astride a horse. Across the street, "parking," are two buggies with one horse each. (Courtesy of Jim Surkamp, Shepherdstown.)

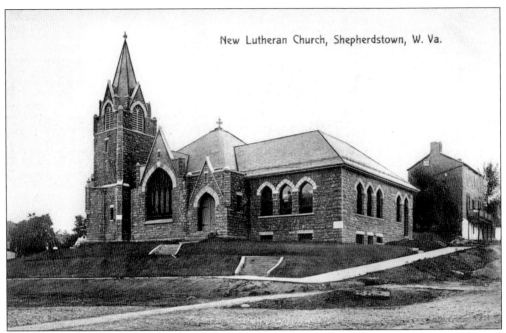

New Lutheran Church, Shepherdstown, W. Va.

St. Peters Lutheran Church sits magnificently on her knoll, ready to care for her flock. This is the "new" Lutheran church, which was constructed around 1906 and dedicated in 1908. Except for the now-paved streets, it doesn't look that much different today. (Courtesy of Jefferson Security Bank, Shepherdstown.)

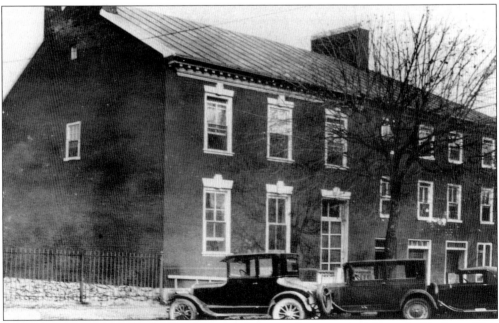

Here is a nice view of the Entler Hotel. Notice the magnificent automobiles parked in front. This photograph probably dates to the 1920s. (Courtesy of Jefferson Security Bank, Shepherdstown.)

This photograph dates to about 1910 and shows the Shepherd Mill property. The mill was located at the corner of High and Mill Streets in Shepherdstown. Thomas Shepherd established two gristmills on the Town Run and also erected a fort to protect the citizenry. (Courtesy of Jim Surkamp, Shepherdstown.)

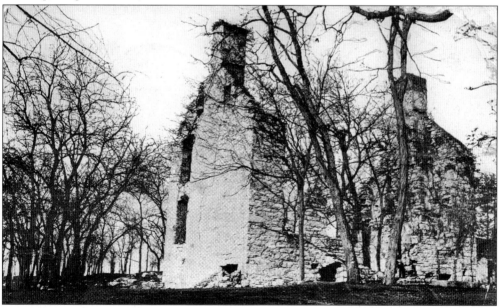

In this 1910 photograph are seen the remains of Fountain Rock. It had been the house of Alexander Boteler's family and was located at the site of the pavilion in Morgan's Grove Park. It was burned in July 1864 just prior to the burning of Bedford by Union general David Hunter, whose cousin was Andrew Hunter, one of the prosecutors in the John Brown trial. (Courtesy of Jim Surkamp, Shepherdstown.)

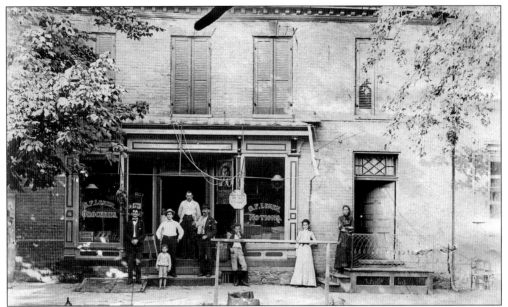

In this 1910 photograph is seen S. F. Lemen's place of business. Mr. Lemen is pictured on the far left, wearing a dark suit. The man standing in the doorway, slightly elevated, is Mr. Adams, who ran Adams Express Delivery Service from Kearneysville. Later the service ran from the Shepherdstown train station. The man in front and slightly to the left of Mr. Adams is Mr. Yontz, a blind man. (Courtesy of Jim Surkamp, Shepherdstown.)

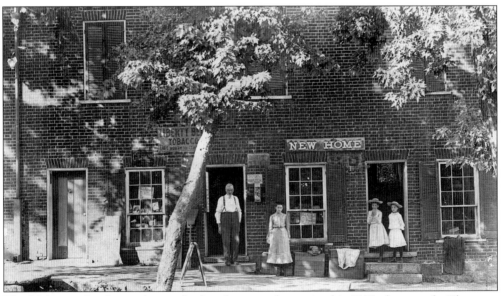

The Maleaster family stands outside their home and store in this 1905 photograph. The store was located due west of the old opera house. While the prices of the items for sale in this store are unknown, some prices in the Sears catalog three years later included one pound of black pepper for 25¢, one can of sliced pineapple for 31¢, a five-gallon can of syrup for $1.89, and 12,000 matches for 58¢. (Courtesy of Jim Surkamp, Shepherdstown.)

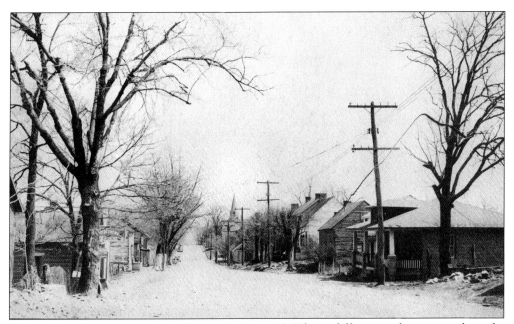

Here is West German Street, also known as Route 45. What a difference a few years make as far as traffic and congestion are concerned. The date of the photograph is uncertain, but notice the telephone poles. (Courtesy of Jefferson Security Bank, Shepherdstown.)

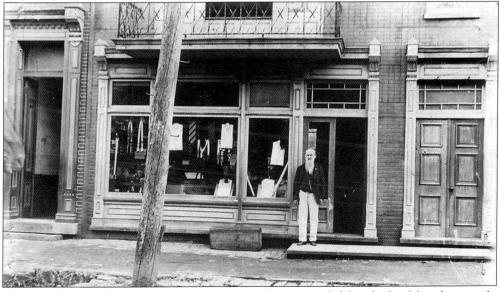

The year is 1910, and a horse's nose can be seen on the extreme left hand side of this photograph. Standing near the doorway is Jacob Wintermoyer, who was a weaver-turned-haberdasher. In the windows, several pairs of suspenders can be seen displayed and available for purchase. His store was located where the future Outback Basics Camp Store would be found. Jacob was a member of the 2nd Virginia Regiment Company B of the Stonewall Brigade, which became renown in the Civil War. (Courtesy of Jim Surkamp, Shepherdstown.)

Shown in this *c.* 1910 photograph is Grandma Show (Elizabeth Catherine Cookus Show) on the left, standing in front of her home at 211 East German Street. The Show House was the second house west of Mill Street, on the north side of the street. The couple to the right of the tree is unidentified. (Courtesy of Margie Redding Blostine, Shepherdstown.)

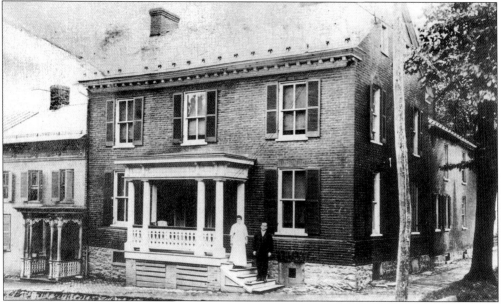

Today this building houses the George Tyler Moore Center for the study of the Civil War. For many years, it was used as the parsonage of the Reformed church. It was called the Conrad Schindler house at one time and is located at Church and German Streets. (Courtesy of Jefferson Security Bank, Shepherdstown.)

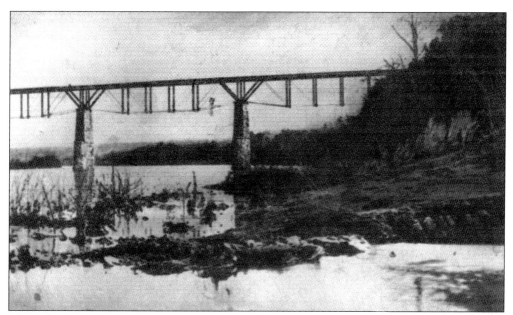

This photograph from the Parks photo collection looks down the Potomac River at Shepherdstown with the railroad bridge visible in the distance. The river forms the boundary between West Virginia and Maryland. Its source is in the Allegheny Mountains, and it winds for a total of 287 miles. Of those miles, 115 are wide and deep enough for large ships. (Courtesy of Jefferson County Museum, Charles Town.)

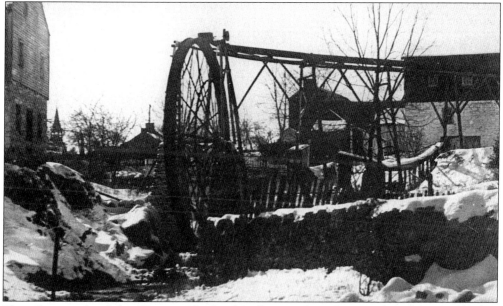

This photograph of the Thomas Shepherd Mill was taken about 1910 looking south from within the Town Run. The wheel seen here was 40 feet in diameter and was manufactured in Martinsburg. Later it would be rolled up the hill to its present setting alongside the mill. The Town Run provided power for Shepherd's gristmill, his early sawmill, and his second gristmill. Other people tried their hands at mills, including gristmills, sawmills, and tanneries. (Courtesy of Jim Surkamp, Shepherdstown.)

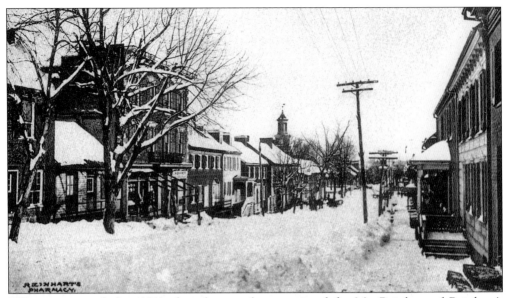

Taken sometime before 1911, this photograph was printed for Mr. Reinhart of Reinhart's Pharmacy by a printer in Brooklyn. It shows a beautiful snow scene looking northeast on German Street. The building on the extreme left with snow on the roof is the site of the future Opera House. (Courtesy of Jim Surkamp, Shepherdstown.)

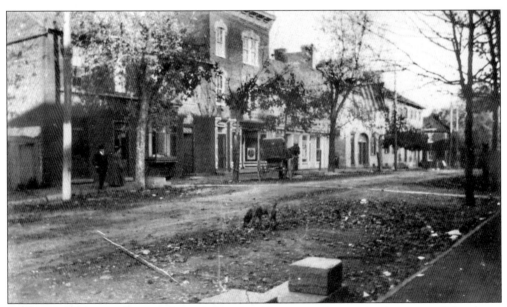

Looking northeast on German Street, a horse and buggy can be seen in the center of the photo. The two light-colored buildings just to the right of the buggy burned in 1912. This photograph was taken from in front of the future Betty's Restaurant, which would become a well-known spot in Shepherdstown. A stray dog can be seen in the center of the photo, just below the buggy. (Courtesy of Jim Surkamp, Shepherdstown.)

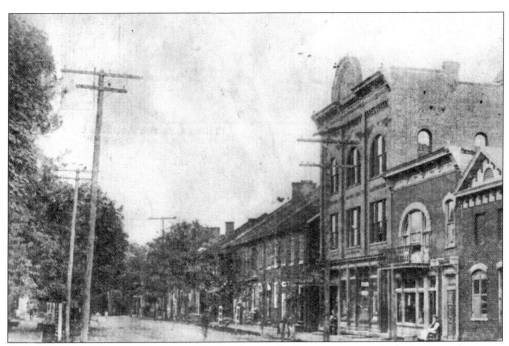

In this picture, German Street in Shepherdstown looks so serene and ideal. A gentleman is seated in a chair in front of a store on the right, seemingly without a care in the world. This photograph was taken before World War I, when times were good and the pace of life was much slower. (Courtesy of Jefferson County Museum, Charles Town.)

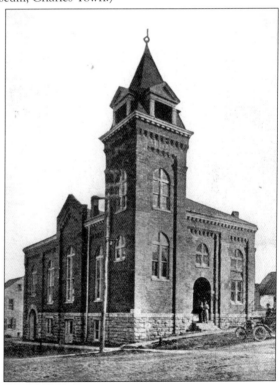

Pictured here is Firemen's Hall. The firefighting equipment of the Shepherdstown Fire Department was housed here until 1990. The building was erected in 1914 on the corner of King and East New Streets. Peter Stuyvesant was one of the first to establish a fire prevention system in New York by having men serve on the "rattle watch," where they inspected neighborhoods and shook wooden rattles to alert people of fire. By the early 19th century, most cities in the country had established volunteer fire companies. (Courtesy of Jefferson Security Bank, Shepherdstown.)

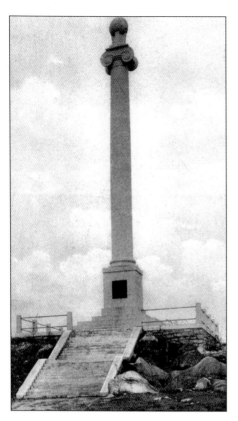

The Rumsey Monument was dedicated in 1915 to commemorate the successful demonstration of the steamboat built by James Rumsey, referred to as "Crazy Rumsey." It was built by William Jackson Britner Sr. Located on the heights overlooking the Potomac River, the monument offers guests a panoramic view of the Potomac and beyond. Rumsey began work on his boat during the summer of 1785, and his experiments culminated with the successful demonstration on December 3, 1787. (Courtesy of Jim Surkamp, Shepherdstown.)

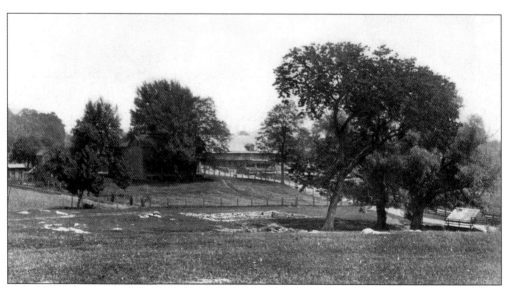

Taken around 1915, this photograph is of the house, barn, and outbuildings of the Willowdale Farm, located about a mile north of Shepherdstown. The house on Willowdale Farm, built around 1830, would later become the Cress Creek Golf and Country Club. (Courtesy of Jefferson Security Bank, Shepherdstown.)

In the center of this photograph sits the Show family home between 1910 and 1920. The view is looking northwest on German Street. The house on the far right is the original poor house from the early 19th century. (Courtesy of Margie Redding Blostine, Shepherdstown.)

Taken from the south looking north, this orchard is the future site of the BB&T Bank. What this orchard grew is unknown. The photograph was taken in the 1920s, and an orchard at that time usually received $2.18 per bushel of peaches, $1.66 per bushel of pears, or $1.24 per bushel of apples. An average farm hand only made $3.30 per day. (Courtesy of Jim Surkamp, Shepherdstown.)

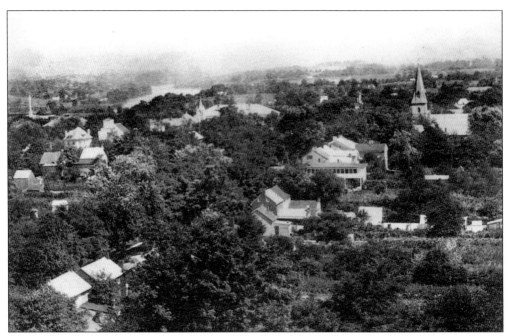

Trees, trees, and more trees are visible in this aerial shot of Shepherdstown in the 1920s. The Potomac River is visible in the distance. This photograph was taken from the southwest with the steeple of the Trinity Episcopal Church visible on the right hand side of the photograph. Obviously it was taken in the summer, as the deciduous trees are in full foliage. (Courtesy of Jim Surkamp, Shepherdstown.)

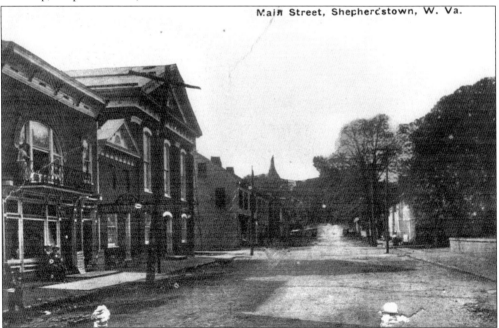

Here is Main Street in Shepherdstown around the 1920s. The name of the street was changed to German Street later. This view is looking north. If you look closely, you will see two people on the left, either seated or standing. (Courtesy of Jefferson County Museum, Charles Town.)

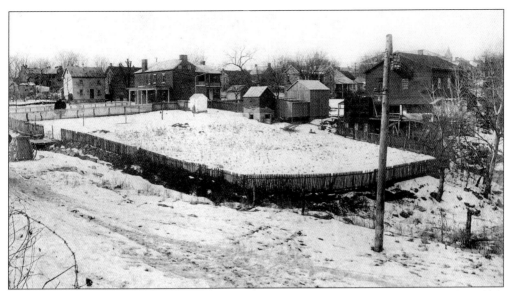

Pictured here is a view looking southwest from Mill Street. On the right, behind the snow-covered fenced field, is the Thomas Shepherd Flour Mill. To the left can be seen a cart, which was owned by Joe Sandbower, a canal boatman. (Courtesy of Jim Surkamp, Shepherdstown.)

This photograph, taken around 1925, looks directly west on German Street, originally called Main Street. The building on the right is the Entler Hotel. At one time, it was also called Rumsey Hall and served as a dormitory for Shepherd College. Although the college was co-ed, dormitories were not. It was this year, 1925, that Shepherd College received an "A" rating by the American Association of Teachers Colleges. (Courtesy of Jim Surkamp, Shepherdstown.)

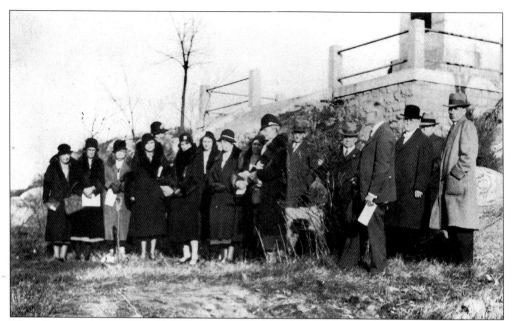

This photograph was taken in the 1930s. It shows a group of people planting the George Washington elm at the James Rumsey Monument. Throughout history, people have planted trees, bushes, and shrubs in honor of important people, and that is what they are doing in this photograph. (Courtesy of Scarborough Library Collection, Shepherd University.)

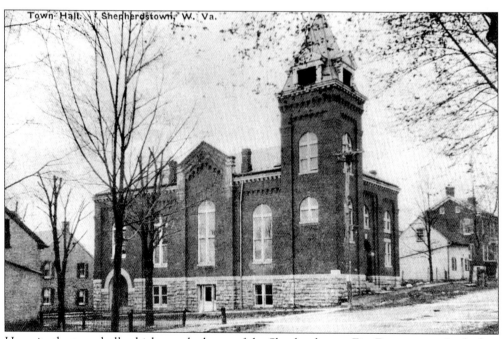

Town Hall. Shepherdstown, W. Va.

Here sits the town hall, which was the home of the Shepherdstown Fire Department. In the late 1950s, three engine bays were added. This building was used until 1989, when a new fire station was built just west of town. (Courtesy of Jefferson Security Bank, Shepherdstown.)

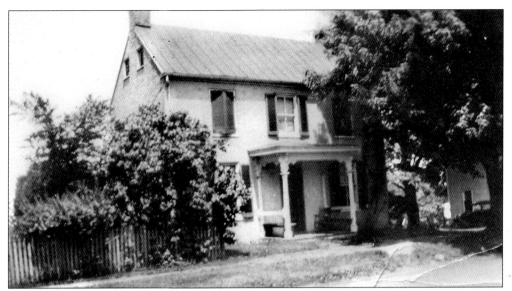

This 1943 photograph shows the Helen B. Pendleton house, which was located on Duke Street. Today the building is owned by the St. Agnes Catholic Church and has served as its rectory. In the mid-1850s, a fire destroyed the original log cabin on this site, owned by James Rumsey, the steamboat inventor who helped put Shepherdstown on the map. The Rumseyan Society exists to this day to preserve James Rumsey's place in history. (Courtesy of Jim Surkamp, Shepherdstown.)

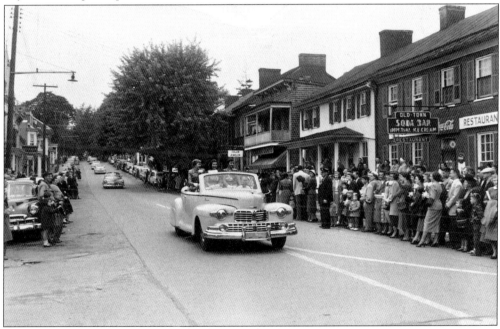

Here is the 1950 homecoming parade as it appeared in the 1951 yearbook at Shepherd College. Notice the way the attendees along the side of the street are dressed. The women are all wearing dresses or skirts and high heels. Many of the men appear to be wearing hats. The attire for the day was not nearly as casual as we see today, that's for sure! (Courtesy of Scarborough Library collection, Shepherd University.)

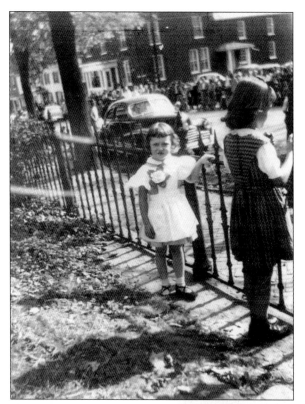

The Shepherd College Homecoming Parade of 1952 is photographed here. The child on the left is Jan Shipley, and the child on the right is unidentified. In the background can be seen the building that was purchased by actress Mary Tyler Moore for scholars to study the Civil War, which had intensely interested Moore's father. (Courtesy of Jan Shipley Roth, Fallston, Maryland.)

Taken about 1953, this photograph shows Main Street (as it was then called) looking south toward the corner of Main and Princess Streets. The little girl on the tricycle is Jan Shipley, and the dog is named Bill. (Courtesy of Jan Shipley Roth, Fallston, Maryland.)

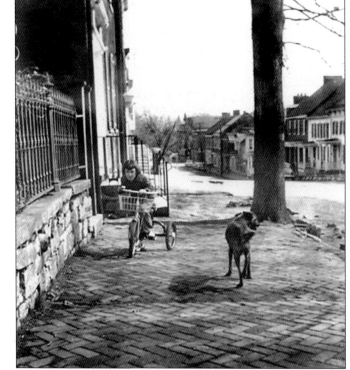

Two

DAY BY DAY

It is the daily lives of individuals that makes history come alive. Most people featured in this chapter had a difficult life. When most of these photographs were taken, there were no efficient vacuum cleaners. There were no digital automatic washing machines or permanent press cycles on dryers. Their dryers were lines in the backyard. They cleaned their houses with old fashioned elbow grease.

Clothing styles for women were far from practical. One can only imagine how uncomfortable women were in long dresses and large hats, especially in the summer. And the men, wearing three-piece suits and hats, ran their errands to the general store and must have been just as uncomfortable as the ladies were.

When we see dogs in the street, remember that they did not have rabies shots yet for pets. If an animal got rabies, it often had to be destroyed. Most of us can remember seeing the scene in the movie *Old Yeller* when they had to destroy the animal in the corn crib. That dog you see in the street in some pictures was a danger to all if he became rabid.

Both men and women served in the armed forces, but generally more men than women, as only men were drafted. During World Wars I and II, the draft was in effect, as it was during the Korean Conflict and the Vietnam War. Everyone who was physically able was required to serve in some branch of the military. There were exceptions for health reasons and educational deferments, and generally, married men were not required to serve. However, near the end of World War II, the government was so desperate for draftees that even married men with three children were drafted. My father was one.

The photos in this chapter are taken from the daily lives of the residents of Shepherdstown.

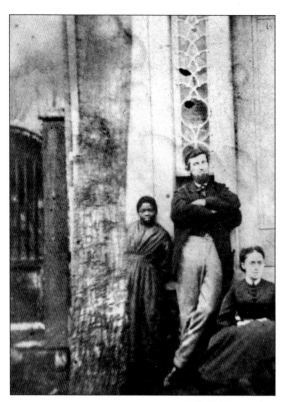

One of the earliest photographs of Shepherdstown was taken in front of the home opposite Trinity Episcopal Church on German Street *c.* 1859. The black girl on the left is believed to be Mamie, a slave who ran away from her owners. The man is Benjamin Franklin Harrison, who was the town's first banker. The woman on the right is unidentified. (Courtesy of Jim Surkamp, Shepherdstown.)

Pictured here is Mary Dare Parren, daughter of Laura Morgan Parren and Dr. Richard Parren. Mary Dare was the aunt of Laura Lee. Mary's sisters included Anna, Laura, and Lily Parren Lee. Their father, Dr. Richard Parren, left Shepherdstown and went to California, where he died in either 1851 or 1852. (Courtesy of Jim Surkamp, Shepherdstown.)

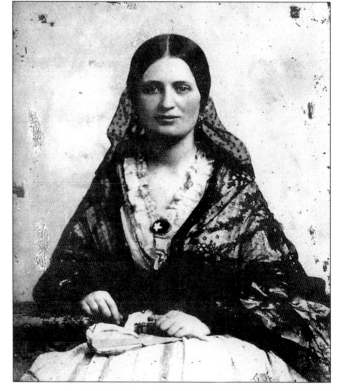

Joseph Line, pictured in this formal portrait, was a very successful tanner in Shepherdstown. Tanning hides involves curing, fleshing, unhairing, and bating hides. Curing prevents the hides from rotting; fleshing removes all fat and meat from the flesh side of the skin; unhairing removes all hair; and during the bating process, the skins are placed in a mild acid bath. After those four processes, the hides are ready to be tanned, which means to prepare the hides for use. (Courtesy of Jim Surkamp, Shepherdstown.)

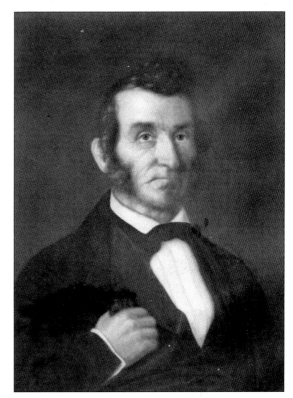

Pictured here is Edmund Jennings Lee III, son of Edmund and Henrietta Lee. Edmund III served as a private in the Confederate States of America's army. This was taken after the war, and Edmund is wearing his Sunday clothes. He had left these clothes at home while he was fighting in the Civil War. (Courtesy of Jim Surkamp, Shepherdstown.)

Edmund Jennings Lee poses in this dignified portrait taken around 1860. Mr. Lee was a town attorney in Shepherdstown during the 19th century. He acquired land from his first wife's father, Abraham Shepherd, and in 1820, he built Leeland, where he and his wife resided. After his first wife passed away, he married Henrietta Bedinger in 1835. Edmund was a first cousin to Robert E. Lee of Civil War fame. (Courtesy of Jim Surkamp, Shepherdstown.)

Standing in the background is James Shepherd. The two women are members of the family of Benjamin Franklin Harrison, who was the first banker in Shepherdstown. The child in the foreground was born in 1854, which dates this photograph to approximately 1860–1865. The house before which they stand faces the Trinity Episcopal Church and was known as the Old Presbyterian Manse. (Courtesy of Jim Surkamp, Shepherdstown.)

It's wash day, and there are no automatic washers or dryers here! People only had the old-fashioned way to wash and dry clothes. This photograph was probably taken in the mid- to late 19th century. By 1908, the Sears catalogue offered several washing machines ranging in price from $2.98 to $6.38. Drying was still left to be done on a clothes line under sunny skies. (Courtesy of Jim Surkamp, Shepherdstown.)

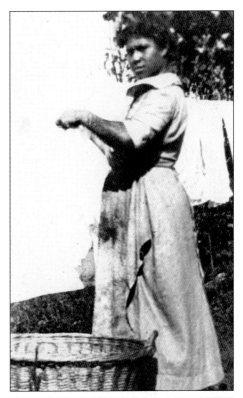

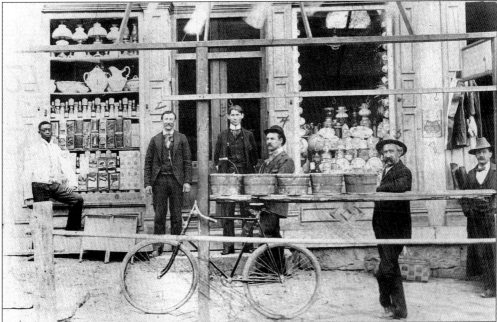

Located on the corner of Church and German Streets was George Billmyer's store. The store appears to have sold lamps and china, probably in addition to other items. The building was constructed in the 1870s. The men in this photograph are unidentified. Note that all are wearing suits and half are wearing hats. (Courtesy of Jefferson Security Bank, Shepherdstown.)

These young ladies seem to have made a game of completing their daily chores. All three are laughing heartily. They probably ascribed to the old adage, "whistle while you work." (Courtesy of Jim Surkamp, Shepherdstown.)

Taken in the 1890s, this portrait shows Mary Bedinger Mitchell, who was born and raised in Shepherdstown. Mary wrote *A Woman's Recollection of Antietam* about the Battle of Antietam. Her sister, Caroline "Danske" Dandridge, wrote history books and was also a poet, well known during her day. In addition, Caroline wrote more than 200 articles about her garden. (Courtesy of Jim Surkamp, Shepherdstown.)

This portrait of Laura Lee Simpson dates from the 1890s. The local paper referred to Laura as "the most beautiful woman in Shepherdstown." She lived in the house opposite what would later become Tommy's Pizza. Unfortunately, she died in her early 30s during childbirth. Her mother, Lily Parren Lee, was a friend of J. E. B. Stuart. Her father, William Fitzhugh Lee, was killed at the First Battle of Manassas in 1861. (Courtesy of Jim Surkamp, Shepherdstown.)

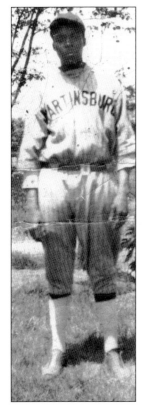

Jim Washington is pictured in his baseball uniform. Jim played for the Martinsburg all-black baseball team, one of such teams established as early as 1861. Interestingly Frederick Douglass's sons played baseball on amateur teams. In 1887, the National Baseball Colored League was formed. In 1912, a racially mixed team was formed by J. L. Wilkinson. It was not until 1947 that the color barrier was crossed in major league baseball by Jackie Robinson. (Courtesy of Jim Surkamp, Shepherdstown.)

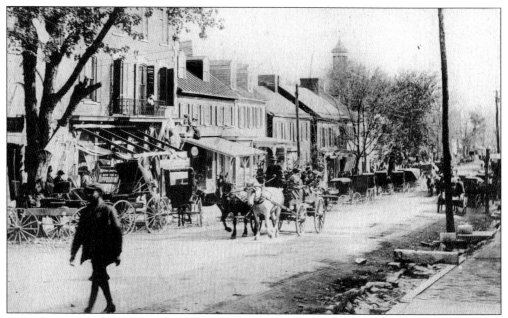

This photograph was taken in the early 20th century. Buggies seem to be everywhere. Maybe this particular day was a shopping day. Traditionally people brought their families to town on a Saturday to do their weekly shopping. In this photograph, the time of the year was either spring or summer, as evidenced by the leaves on the trees. (Courtesy of Jefferson Security Bank, Shepherdstown.)

This early-20th-century photograph was taken by the Leeland House. Pictured here is the mayor of Pittsburgh, who was visiting the Goldsborough family at the time. Mayor Scully is the gentleman pictured in the center of the photo wearing dark slacks, a white shirt, and a dark tie. The other people are not identified but are very likely family and friends. The Scully family summered in Shepherdstown. (Courtesy of Jim Surkamp, Shepherdstown.)

St. Peter's Lutheran Parsonage benefited from the excellent masonry work of these well-known local masons. From left to right are sons Charles David "Snooks" Jones, Woodrow W. "Babe" Jones, Ernest W. "Tootie" Jones, and father Charles E. "Big Mustache" Jones. Obviously nicknames were popular at that time. (Courtesy of Jefferson Security Bank.)

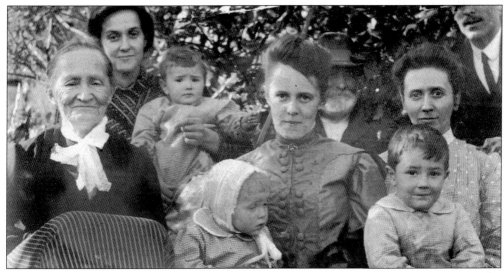

Margie Britner is pictured in the center of this photo holding the small child. To the left, in the front row, is Grandma Show. Others are unidentified. The Britner family and the Show family were both very important and prominent in Shepherdstown. The photograph dates from the early 20th century. (Courtesy of Margie Redding Blostine, Shepherdstown.)

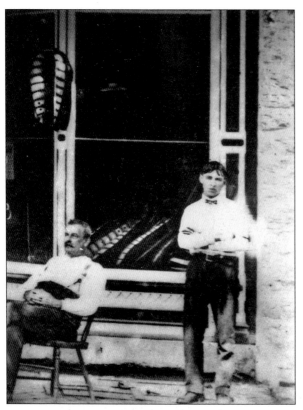

This early-20th-century photograph shows Mr. Lichlider outside of the harness shop on German Street. Before automobiles were widely used, horses and buggies were the most common means of transportation. According to the 1908 Sears catalogue, a typical harness cost from $12.96 for a regular, single-strap buggy harness to $16.98 for a solid nickel, German silver–trimmed harness. (Courtesy of Jim Surkamp, Shepherdstown.)

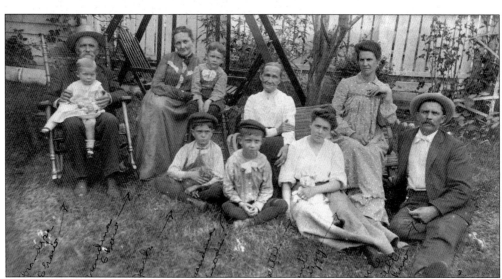

Here the Show family relaxes on the grass. From left to right are (first row, seated on grass) Jack (holding a pet chicken); unidentified boy; Gertie; and Uncle Walt Show; (second row) Grandpa Show, holding a baby; Grandma Show, sitting next to a small child; Grandma Knode; and Aunt Lizzy. Family gatherings such as these have always been very important to the families of Shepherdstown. (Courtesy of Margie Redding Blostine, Shepherdstown.)

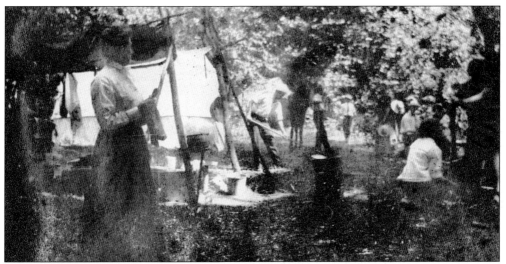

Recreational camping has been popular for many years. The Morgan Grove Fair was held every year at Morgan Grove Park until the 1920s or 1930s. The fair lasted three or four days and included amusement rides in addition to camping. Even though the women are camping, they are still dressed in the appropriate attire—long dresses and hats. (Courtesy of Jim Surkamp, Shepherdstown.)

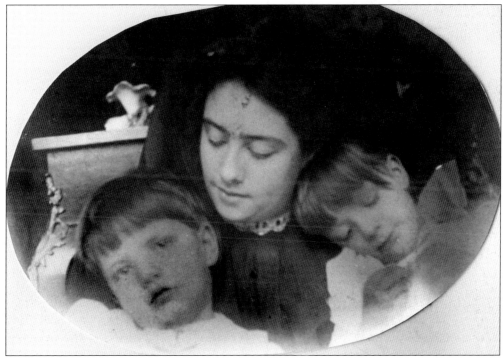

In this early-20th-century photograph is a nanny with her arms around two children in her care. On the left is Lee Goldsborough and on the right is Helen Goldsborough, both of the Shepherdstown Goldsborough family. Obviously the Goldsborough family was wealthy enough to afford a nanny. (Courtesy of Jim Surkamp, Shepherdstown.)

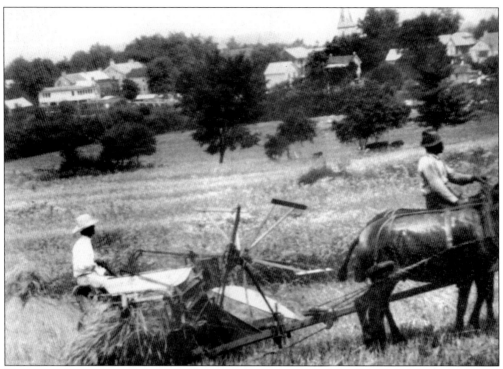

Haying is taking place in this early-20th-century photograph of the Goldsborough property. The man to the right appears to be Abe Minier. These men were probably day laborers. Often day workers were offered wages that included board. If they chose that option, they received a smaller hourly wage than the workmen who did not take the board. (Courtesy of Jim Surkamp, Shepherdstown.)

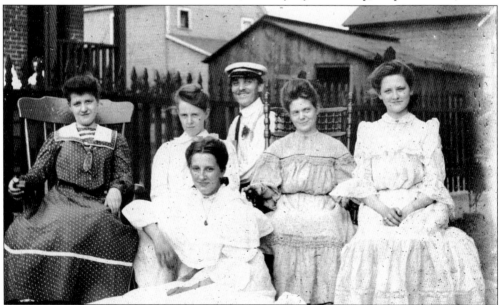

Taken in 1903, this photograph is of family and friends. The man in the back is Mr. Carl Britner, and his wife is located to his immediate right (second row, second from left). Other people are unidentified. All seem to be very stylishly dressed. (Courtesy of Margie Redding Blostine, Shepherdstown.)

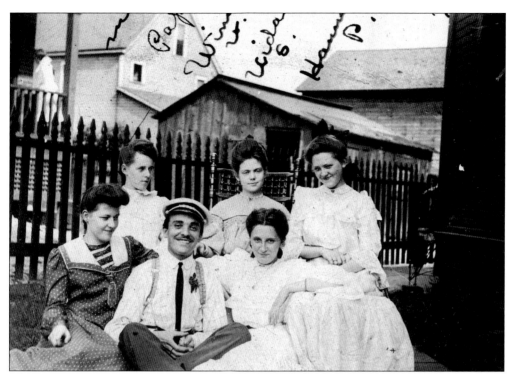

The gentleman in the front row of this photograph is the husband of Margie Britner, who is the lady on the extreme left in the back row. Other women are friends of the family. Mr. Carl Britner seems to be a rather popular and debonair fellow. This photograph is from the early 20th century. (Courtesy of Margie Redding Blostine, Shepherdstown.)

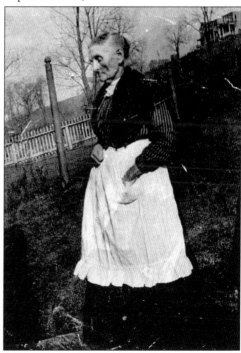

Taken about 1905, this photograph shows a very determined woman, Mary Catherine Freese Britner. Her husband was Gregory Britner, who had fought for the Confederacy. Mary was a modern woman for her day—she was a feminist. Wearing the mandatory apron, Mary seems to be preoccupied with events of the day. Women at that time were expected to stay at home and take care of the house and other family members, and Mary Britner was no exception. (Courtesy of Margie Redding Blostine, Shepherdstown.)

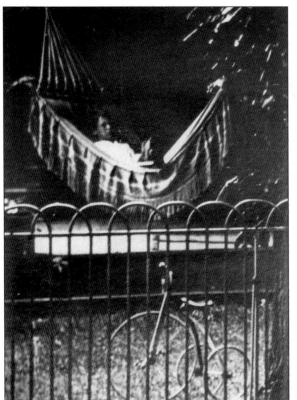

A member of the Potts family relaxes in a hammock on the front porch of a home owned by Mrs. Ruth Thacher of New Street. The date of the photograph is uncertain. Hammocks were offered for sale in the 1908 Sears catalogue from 92¢ to $3.38 for a more decorative and elaborate style. Notice the velocipede against the iron fence. A velocipede (tricycle) could be purchased in the 1908 catalogue for anywhere from $1.25 to a whopping $7.13! (Courtesy of Jim Surkamp, Shepherdstown.)

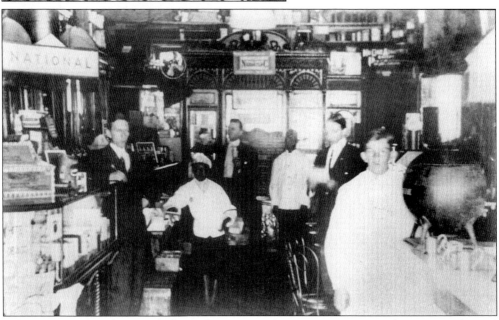

Taken in 1910, this photograph shows the interior of Owens' Drug Store. The store was located on German Street in the Register Building. The pharmacist, Charles R. Owens, is standing second from the right. The other men are not identified. A drug store often served refreshments in addition to carrying medications. (Courtesy of Jefferson Security Bank, Shepherdstown.)

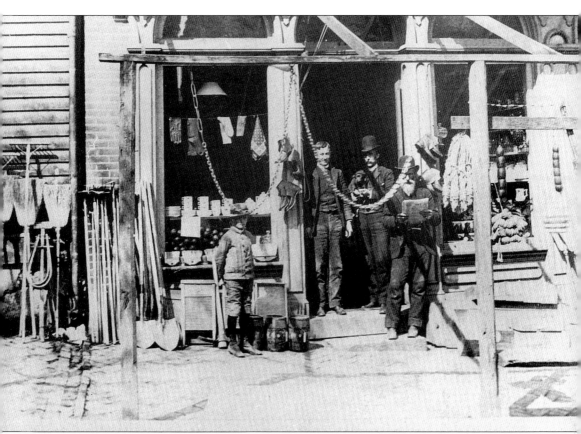

Items offered for sale at this store include brooms, rakes, shovels, hoes, washboards, chains, shoes, socks, gloves, and many others. The store was located in the old Independent Building on German Street, but the owner of this store is unknown. The photograph was taken around 1910. (Courtesy of Jefferson Security Bank, Shepherdstown.)

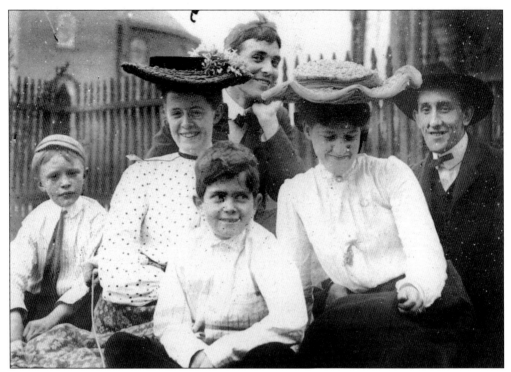

The impish grin on William Jackson Britner Jr., known as Jack, in the front row makes one wonder what he's been up to! Behind him, in the dotted blouse and dark hat, sits Margie Britner. Taken in 1910, this photograph shows six Britner family members. Style and fashion abound in this image—notice the ladies' rather elaborate hats! The gentleman in the right rear of the photograph is William Jackson Britner, known as Will. (Courtesy of Margie Redding Britner, Shepherdstown.)

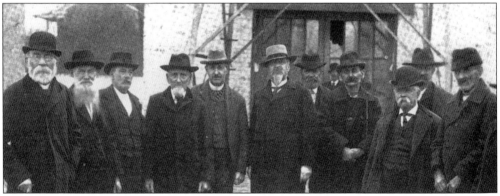

Standing in front of the then fire house are a group of Confederate veterans. This fire house served as the library starting in 1922. Pictured from left to right are John George Unseld, Jacob Wintermoyer, Harry Lyons, David Hout, George E. Adams, Frank Jones, John Philip Entler, Joseph Yontz, Edward Lucas, Charles Ferrell, William Arthur, and Post Humrickhouse, with G. W. Ferrell in the rear. (Courtesy of Jim Surkamp, Shepherdstown.)

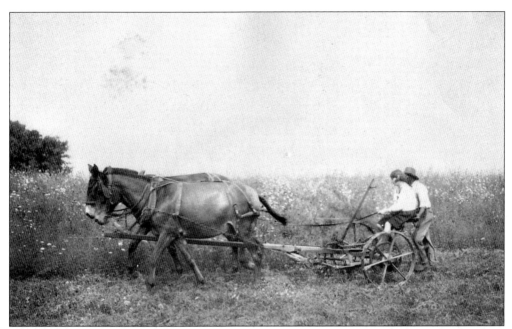

Abe Meiner is helping with farming chores on the Goldsborough property, Leeland. Taken around 1915, the farm machinery is being pulled by a pair of sturdy stock. The average daily wage for a farmhand at that time was $1.40 without board and $1.10 with board. On a monthly basis, without board, a farmhand earned $30; with board, $22.50. Those wages were paid at a time when a dozen eggs sold for 34¢ and a pound of butter sold for about 36¢. (Courtesy of Jim Surkamp, Shepherdstown.)

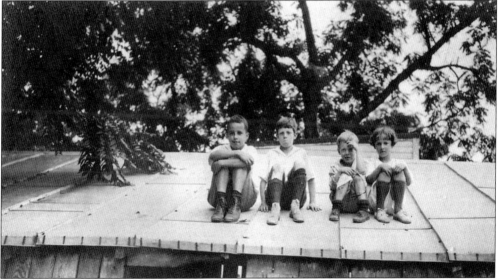

These boys seem to be thinking, "Now, how do we get down?" Sitting on the roof of a building on either the Scully Farm or Leeland are, from left to right, Bill Jarret, Bud Scully, Jack Scully, and Olivial (Pete) Jarret. This photograph was taken during the first half of the 20th century, when climbing on top of buildings was a fun activity, albeit a little dangerous. (Courtesy of Jim Surkamp, Shepherdstown.)

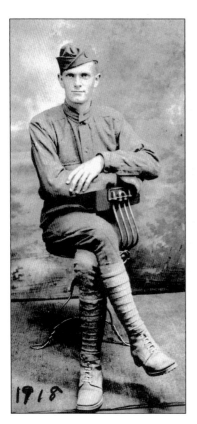

Here is a 1918 photograph of William Jackson Britner Jr. (Jack). Another photograph of him as a boy can be found on the top of page 60. He was a soldier who suffered from mustard gas poisoning during World War I. Many Britner family members have lived in Shepherdstown over the years. (Courtesy of Margie Redding Blostine, Shepherdstown.)

An extremely happy couple is pictured here, very likely at a family gathering. Whether it was an anniversary or another celebration is not known. The photograph is from the first half of the 20th century. (Courtesy of Jim Surkamp, Shepherdstown.)

These two men proudly display their hunting successes. Hunting for pleasure or for food has always been popular in America. The right to own a gun is guaranteed by our constitution, and hunters would bemoan the loss of that right. The animals in this photograph were very likely used for food, as is the case with most animals that are hunted. (Courtesy of Jim Surkamp, Shepherdstown.)

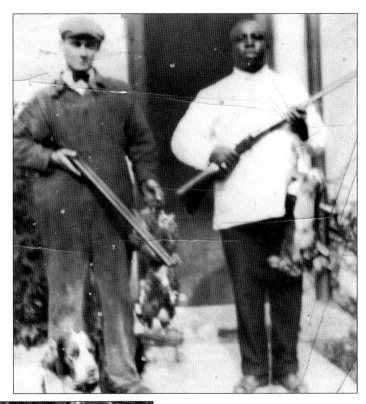

Pictured here are two successful small-game hunters. Traditionally, hunting has been a sport for men, although it is becoming increasingly popular with women. Each jurisdiction in the country enforces its own laws regarding hunting with respect to age, length of season, and so on (Courtesy of Jim Surkamp, Shepherdstown.)

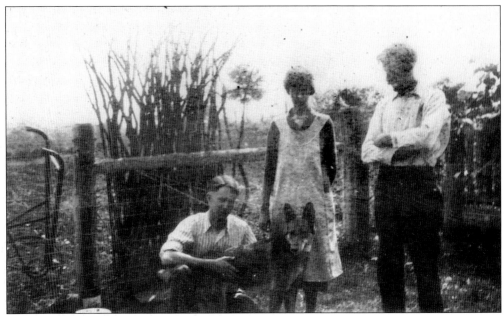

From left to right are pictured Dick Britner, Margie Britner Littler, and William J. Britner. The dog, named Sir Dicks, was purchased for $300 during the Depression, when money was tight for most people. When infant Dick Britner wandered onto Route 480, Sir Dicks, a very strong show dog, pulled him home to safety. (Courtesy of Margie Redding Blostine, Shepherdstown.)

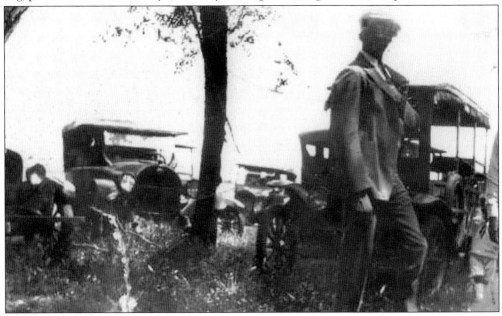

Mr. John Dean from Shepherdstown glances at the camera as he strolls over to the picnic area. This photograph was taken in the 1920s in Boyce, Virginia, where there was a picnic area that was frequented by African Americans on weekends. As a rule, African Americans were not welcome at any of the "white" picnic areas during those times. That would not change until after the Civil Rights Act of the 1960s. Numerous automobiles, many of them Model Ts, can be seen in the background. (Courtesy of Richard Clark, Shepherdstown.)

Pictured here is Mr. Abe Meiners, who was employed at Leeland. Leeland was the property owned by the Goldsborough family. Mr. Meiners helped in several capacities including haying, as is seen in the photograph on page 56. This photograph was taken in the 1920s. The average pay for a farmhand in 1920 was $2.80 per day with board and $3.30 without board. (Courtesy of Jim Surkamp, Shepherdstown.)

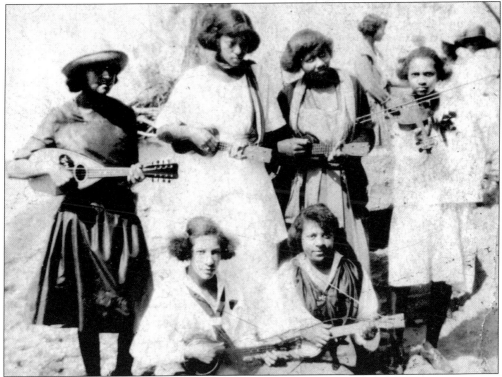

In this 1920s photograph, a group of young string players pose with a variety of instruments. Several different types of stringed instruments could be ordered through catalogues such as Sears. For example, the 1908 catalogue offered violins, guitars, mandolins, and banjos, ranging in price from $1.85 to $69—a price for every budget. (Courtesy of Jim Surkamp, Shepherdstown.)

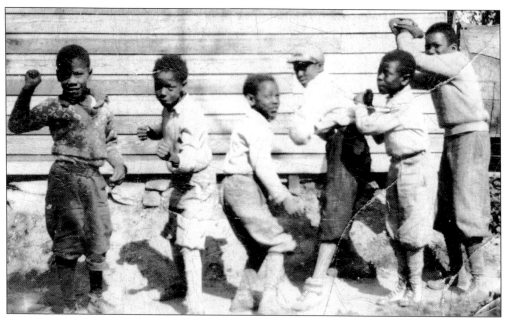

Pictured in this 1920s photograph are, from left to right, Wallace Robinson, Gordie Clark, Warren Clark, Burton Brown, Adrian Robinson, and Henry Washington. Posing in various boxing positions, they show off their expertise in the sport. It was in the late 19th century that a circuit of black boxers arose. Black boxer Jack Johnson, who had earned the heavyweight championship from Tommy Burns in 1908, was probably one of their role models. (Courtesy of Richard Clark, Shepherdstown.)

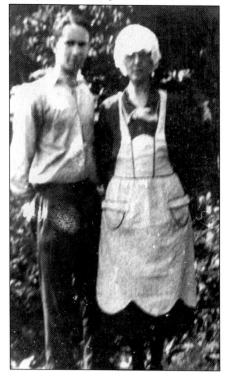

This 1925 photograph is of Richard Britner on the left and Margie Blossom Britner Littler on the right. Margie is wearing a "dust cap" because they were in the process of cleaning house. Richard attended Shepherd College. (Courtesy of Margie Redding Blostine, Shepherdstown.)

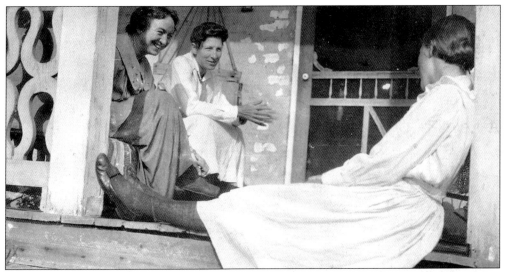

Relaxing on the porch are three ladies enjoying a friendly afternoon chat in the 1930s. Most women did not work outside the home, and juvenile delinquency was hardly considered to be a problem. (Courtesy of Jim Surkamp, Shepherdstown.)

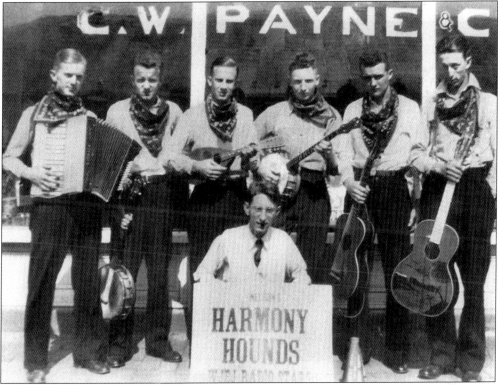

Standing in front of C. W. Payne and Company, which was a farm implement dealership, are the Harmony Hounds. These local musicians performed during the 1930s. Pictured from left to right are Charles "Bus" Miller, "Tuck" Knode, Grover Knode, Bernard Byers, Kenneth Myers, and Paul Byers, and kneeling in the front is Albert Nelson. (Courtesy of Jefferson Security Bank, Shepherdstown.)

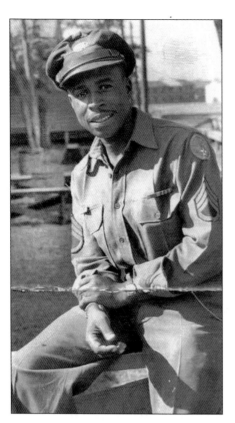

The chevrons worn on the upper arm by World War II soldier Charles Boyd indicates that he is a sergeant in the U.S. Army. All military personnel wear an insignia that indicates their rank. The use of insignia probably began in 1097 when the Crusaders used symbols of shields to identify themselves and their cause. The U.S. Army's use of insignia dates to 1775, when militia officers were ordered by Washington to wear rosettes to indicate their rank. (Courtesy of Jim Surkamp, Shepherdstown.)

Here sits the nephew of Gertrude Schley of Shepherdstown. He served his country admirably in World War II. After World War II, it is not known if he returned home safely. However, there were a total of 405,399 deaths in World War II. Of those, 291,557 were combat deaths, and 113,842 were other deaths/non-combat deaths. In addition, 670,846 servicemen were wounded but not mortally. (Courtesy of Jim Surkamp, Shepherdstown.)

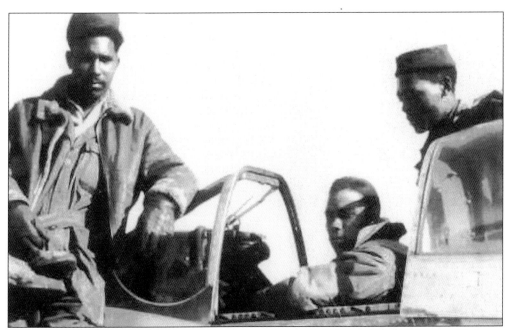

Pictured here are men from Shepherdstown when they served during World War II as Tuskegee Airmen. The role of African Americans as pilots increased during World War II. From 1942 to 1946, there were more than 15,000 men and women who shared in the Tuskegee experience. Prior to 1940, African Americans were not permitted to fly for the military, but in 1941, the first African American squadron was formed in Tuskegee, Alabama. (Courtesy of Jim Surkamp, Shepherdstown.)

Wallace Smith wears his World War II U.S. Army uniform. How long he served is not known, but the average enlisted serviceman served for a total of 33 months; officers served an average of 39 months. During World War I, enlisted men served an average of 12 months; officers served an average of 14 months. (Courtesy of Jim Surkamp, Shepherdstown.)

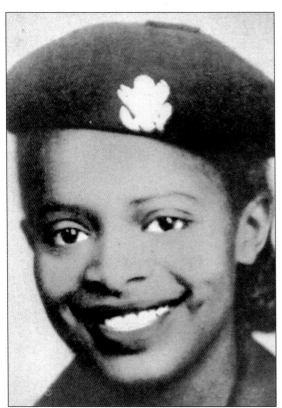

The daughter of Bud McCann is pictured here, wearing her World War II military beret. Of all of the military personnel, 70 percent would serve an average tour of duty of 16.3 months overseas. (Courtesy of Jim Surkamp, Shepherdstown.)

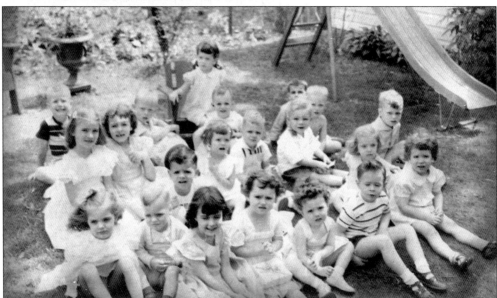

Children pose for the camera in 1951. This was Jan Shipley's fourth birthday party. Pictured are, from left to right, (first row) unidentified, Jan Shipley, Sharon Fuss, unidentified, Jane Crane; (second row) Donna Phillips, unidentified, Tommy Price, Cheri Carter, and three unidentified people; (third row) David Derr, Ronny Starry, and Billy Bland. Sitting in a chair by the tree is Nancy Maddex. (Courtesy of Jan Shipley Roth, Fallston, Maryland.)

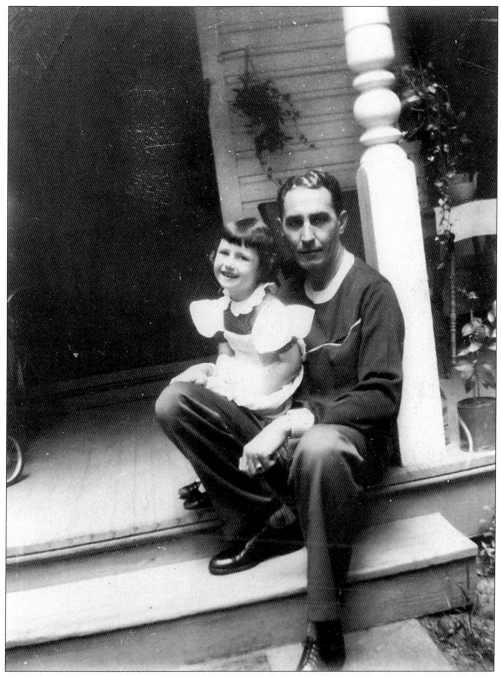

Jan Shipley sits on her daddy's lap on the front porch of their Shepherdstown home. The house was located next to the Presbyterian manse. Jan lived with her parents, Charles Waldron Shipley and Jean Marie Shipley, and grew up in Shepherdstown. This photograph dates from about 1951. (Courtesy of Jan Shipley Roth, Fallston, Maryland.)

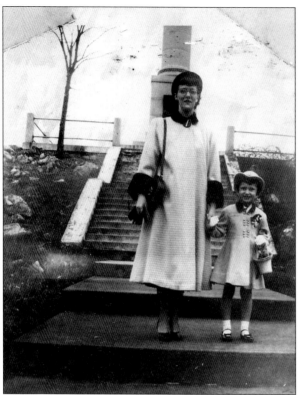

Mrs. Jean Marie Shipley poses with her daughter, Jan, in front of the Rumsey Monument. This photograph dates from about 1952. This photograph appears to be taken in the very early spring, as no leaves are present on the deciduous trees. Mr. Shipley, Jean's husband and Jan's father, would become a prominent educator in Jefferson County; eventually, a Charles Town elementary school was named C. W. Shipley Elementary School in his honor. (Courtesy of Jan Shipley Roth, Fallston, Maryland.)

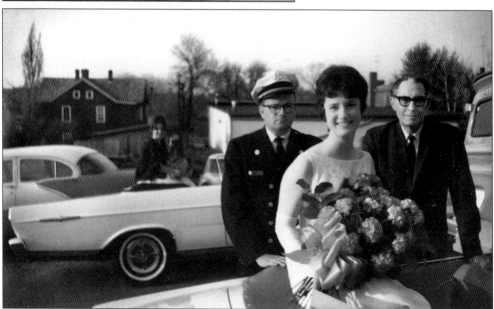

The Winchester Apple Blossom Festival parade took place in May 1965. The honorary fire chief for the Shepherdstown Volunteer Fire Department was Jan Shipley, pictured here in her gown, holding her flowers in her lap as she sits in a convertible. Her father, retired fire chief C. W. Shipley, is on her left, and behind her on her right is the fire chief at that time, D. Lee Morgan. (Courtesy of Jan Shipley Roth, Fallston, Maryland.)

Three

EDUCATION

Formal education was established in Shepherdstown in 1847 when two districts were created: western and eastern, Potomac and Shepherd, respectively. Eventually in 1880, those two districts would join to form a consolidated school. In 1900, the old jail was purchased, the building razed, and a new graded school, which taught grades one through eight, was constructed on the lot. In 1957, Shepherd Elementary replaced that school. Later Shepherd College purchased the building for the use of its social studies department.

Under the principalship of Joseph McMurran, Shepherd College opened on September 2, 1871, with 22 students, who attended classes in what is now called McMurran Hall. Less than a full calendar year after it opened, Shepherd College was admitted into the State Normal School System of West Virginia on February 27, 1872. The college also handled grades 10, 11, and 12 for public-school students.

Prior to the formation of public schools, there were private schools in town—at least 20.

Education for black students took longer to become established. Old School on Brown's Alley was the first school for black students. It was a one-room school and operated until 1883. Old School was replaced by Shadyside on West High Street. If students wanted to continue their education beyond elementary school (grades one through eight), they could attend Page-Jackson High School in Charles Town. It was a school for black students. Segregated schools would continue until 1955, when all schools were integrated.

A new Shepherdstown High School was built from bond money approved in 1928. It would not be until 1971 that Jefferson County High School would be constructed.

Ironically, College Street in Shepherdstown was so named in 1798, long before a college ever existed in the town. Maybe the use of that street name so early in the life of the town was foreshadowing its future.

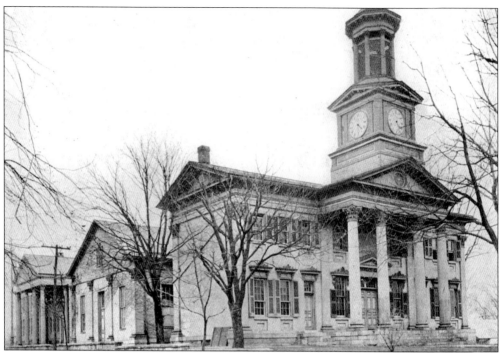

These buildings were the earliest of Shepherd College. On the extreme left is Knutti Hall, next is Reynolds Hall, and on the right is McMurran Hall. Knutti was not the first college building to be erected on this site. In 1897, the original building was constructed, but it burned in 1901. (Courtesy of Jefferson Security Bank.)

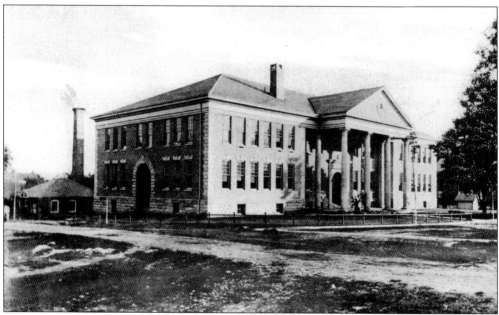

Here is a photograph of a new building for Shepherd College. Named Knutti Hall, it was the early 20th century when it was constructed. The previous building which had occupied the site of Knutti Hall was destroyed in 1901 by fire. (Courtesy of Jefferson Security Bank, Shepherdstown.)

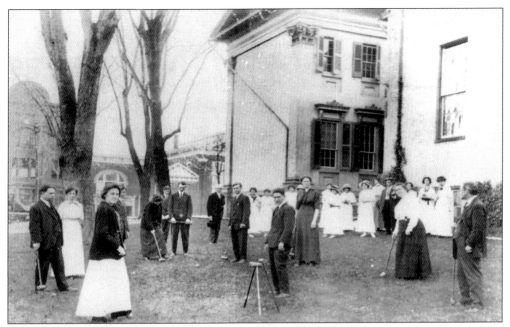

Here is a croquet match being held on the McMurran Hall grounds. Notice all the men are wearing suits, and all of the ladies are in long dresses. Many of the women who are wearing the white dresses are also wearing hats. The date of this photograph is not certain, but it was probably taken around the turn of the century. (Courtesy of Jefferson Security Bank, Shepherdstown.)

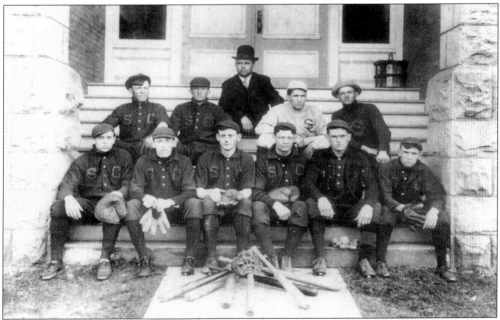

Pictured here is the Shepherd College baseball team. Taken in the early 20th century, the team is posing on the steps of Knutti Hall. In front of these men can be seen a stack of baseball bats and a catcher's mitt. Their uniforms include what appear to be knee pants—maybe knickers— with stockings, shoes with cleats, and button shirts with "SC" in block letters to identify their college. (Courtesy of Jefferson Security Bank, Shepherdstown.)

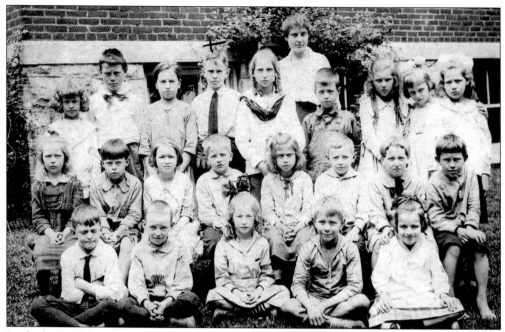

In the back of this class photograph is the teacher, who was not all that much taller than the kids. The boy in the back row with an "X" over his head is Dick Britner. The boys outnumber the girls. With only 22 students in the class, more learning could take place than in the more crowded classrooms today. (Courtesy of Margie Redding Blostine, Shepherdstown.)

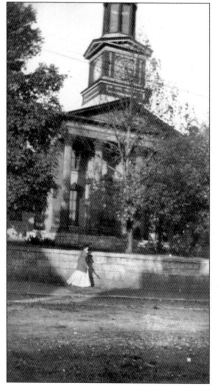

McMurran Hall of Shepherd College is pictured in this photograph taken between 1910 and 1915. A woman walks in front of the building and appears to be carrying either a cane or a parasol, as shown in the shadow. Mr. Joseph McMurran was considered to be the founder of the college, although many others helped in this endeavor. The building served as the Jefferson County Courthouse for a short time. (Courtesy of Margie Redding Blostine, Shepherdstown.)

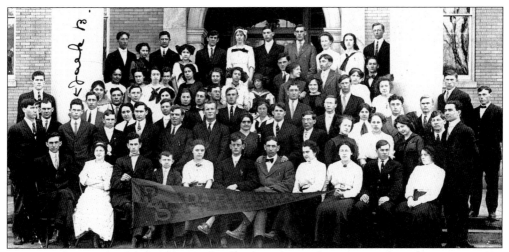

Here is a class at Shepherd College. The class has almost the same number of women as men, which was atypical of the times. In most instances, two to three times more men than women graduated from college. Maybe Shepherdstown, and specifically Shepherd College, was ahead of its time. (Courtesy of Margie Redding Blostone, Shepherdstown.)

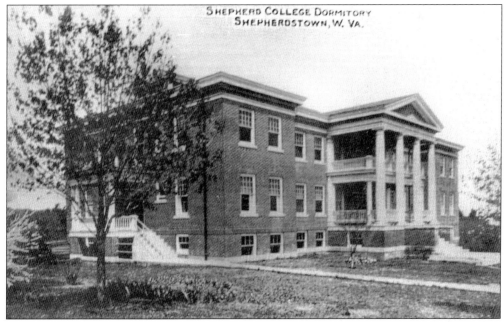

Miller Hall is pictured here in this 1920s photograph. Miller Hall was a girls' dormitory. Traditionally, all dormitories were single-sex with restricted hours and access. Co-ed dorms would not come until sometime in the 1960s. Not all colleges and universities would adopt the co-ed dorm policy. Later many colleges and universities would also offer apartments for married students. (Courtesy of Jefferson Security Bank, Shepherdstown.)

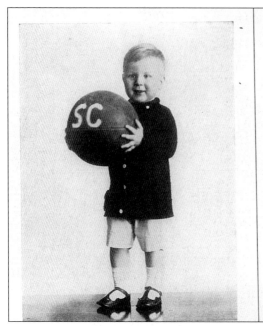

OUR MASCOT
W. H. S. WHITE, Jr.

Pictured here is W. H. S. White Jr., who was the 1921 Shepherd College mascot. His father, W. H. S. White, was the president of the college from 1920 to 1947. Eventually, the mascot became an attorney in Jefferson County. (Courtesy of Jefferson Security Bank.)

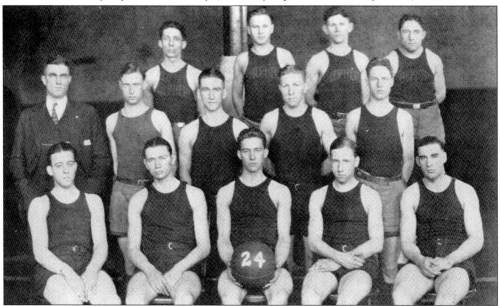

The 1924 Shepherd College basketball team is pictured here. Men from Shepherdstown are identified with "ST" after their names. The players, from left to right, are (first row) Rudolph Lowe (ST), Charles R. Davis (ST), Cletus D. Lowe (ST), Allison Rider, and Whitney T. Michael; (second row) coach W. R. Legge, Files L. Robinson (ST), Daniel B. Lucas (ST), Luther W. Thompson, and E. Holmes Reinhart; (third row) Newton B. McKee (ST), Cedric O. Reynolds, Upton S. Martin Jr. (ST), and William F. Musser (ST). (Courtesy of Jefferson Security Bank, Shepherdstown.)

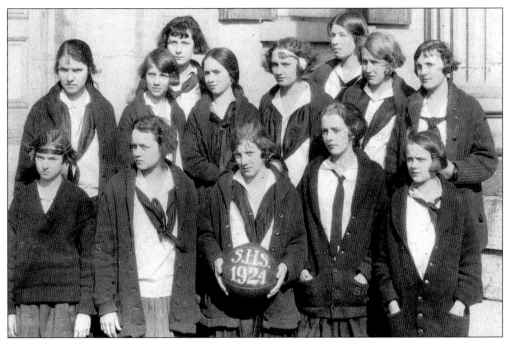

Pictured here are members of the girls' basketball team of Shepherdstown High School in 1924. Notice that the girls all wear what appears to be a school uniform. Also, the hairstyle called the "bob" was very popular. It appears that quite a few girls went out for basketball. (Courtesy of Jim Surkamp, Shepherdstown.)

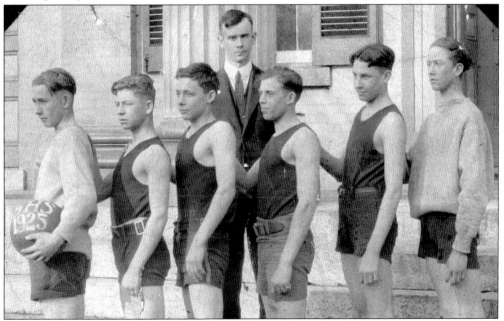

Here some members of the Shepherdstown High School men's basketball team of 1925 pose. Whether this is the varsity or junior varsity is not known, but it does seem rather small for a varsity team. About the time of this photograph, the price for a basketball ranged from $1.45 to $2.70, and a hoop went for $2.74. (Courtesy of Jim Surkamp, Shepherdstown.)

This building was the physical education building, located on the corner of High and Princess Streets on the Shepherd College campus. It was dedicated in January 1925 and was officially named White Gymnasium in 1927. In 1959, it was renamed White Hall, and the building was converted to classrooms. Eventually, it was torn down and replaced with a modern building for classrooms. (Courtesy of Jefferson Security Bank, Shepherdstown.)

Pictured here is the Entler Hotel. It was purchased by the State of West Virginia in 1921 for $10,500 to be used as a college building. It was named Rumsey Hall in 1927, after the illustrious Shepherdstown inventor. Until 1953, when Boteler Hall was built, Rumsey Hall was the only men's dormitory on the Shepherd College campus. (Courtesy of Jefferson Security Bank, Shepherdstown.)

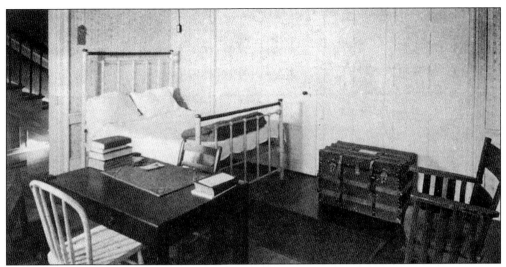

Pictured here is a typical room in Rumsey Hall. The photograph is from 1929. The room appears austere compared to dormitory rooms of today. Shepherd College began as a private college in 1871. The next year, it became the State Normal School. It held its first summer school in 1908 for a period of six weeks. It was not until 1930 that Shepherd College became a four-year college with authority to grant degrees, and it was one year later that 18 graduates received college degrees from what was then Shepherd State Teachers College. (Courtesy of Jefferson Security Bank, Shepherdstown.)

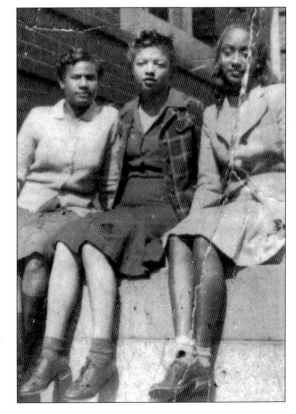

Three fashionable ladies sit on the concrete steps of their school building, probably waiting for classes to begin. Based on the style of the shoes these young women are wearing, it can be assumed that this photograph dates to the 1930s or 1940s. These students attended segregated schools and would continue to do so until the mid-1960s. (Courtesy of Jim Surkamp, Shepherdstown.)

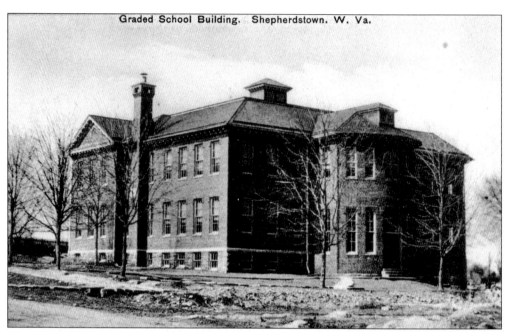

Here is the Graded School Building about 1900, located on North King and West High Streets in Shepherdstown. The rear of the building had a fire escape tube that was added after 1920 and extended from the second floor window to the ground. This building was open to white students only until the mid-1960s. As early as 1762, both an English and a German school existed in town. West Virginia's first free school was the Shepherd District Free School located on Princess Street and opened in 1845. It remained open until 1881. (Courtesy of Jim Surkamp, Shepherdstown.)

This timeless photograph of Shepherd College shows that Shepherdstown does indeed get a little snow now and again. The snow appears undisturbed, which might indicate that the college was between semesters at the time of this photograph. (Courtesy of Jim Surkamp, Shepherdstown.)

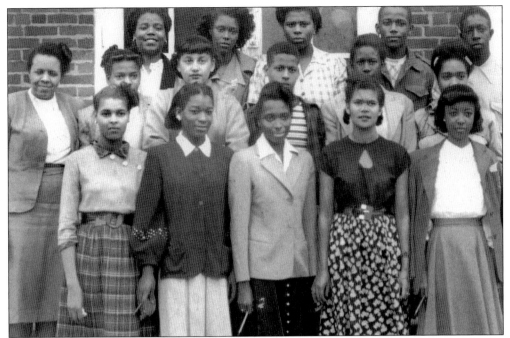

Education for African American students in Shepherdstown was limited. As evidenced by the attire of these students, they took their education very seriously. The only high school in the county, Jefferson High School, did not accept them. Therefore, they had to attend Eagle Avenue School in Charles Town. It would not be until 1938 that Page-Jackson High School in Charles Town would open for African American students. (Courtesy of Jim Surkamp, Shepherdstown.)

Charles Waldron Shipley, second from the left, is pictured here as part of the graduating class of Shepherd State Teachers College in 1942. Mr. Shipley became an important educator in Jefferson County. The next year, 1943, the college broadened its programs and changed its name back to Shepherd College. (Courtesy of Jan Shipley Roth, Fallston, Maryland.)

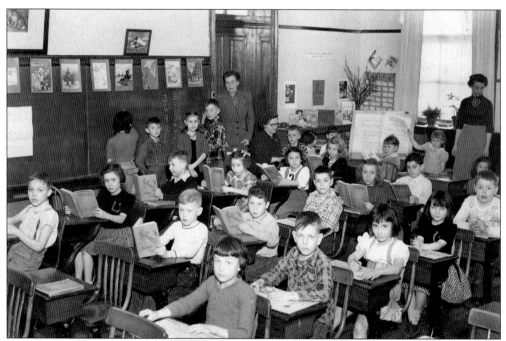

Elementary students wait patiently for the lesson to begin. The woman standing in the back center of the room is Mrs. Lowe, the teacher. The woman standing in the right rear of the room is Phyllis Kimble, a student teacher from Shepherd College. Mrs. Florence Shaw was the advisor for this student teacher. (Courtesy of Scarborough Library collection, Shepherd University.)

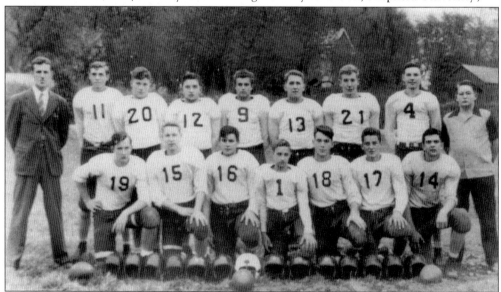

Pictured here is the Shepherdstown High School football team from 1947. From left to right and including jersey numbers are (first row) Berry Carter, 19; Nevin Strider, 15; Jim Blackford, 16; ? Shriver, 1; Jim Bonner, 18; Rick Goodwill, 17; and Jim Price, 14; (second row) Kenny Rentch, coach; Lowell Fritts, 11; Alvin Russell, 20; Bobby Gano, 12; Sylvester Housden, 9; Greg Shipley, 13; Gary Sager, 21; Bill Cline, 4; and Bill Hammond, manager. (Courtesy of Jefferson Security Bank, Shepherdstown.)

Mrs. Jean Marie Shipley stands beside Dr. Joseph C. Humphrey, formerly of Lubbock, Texas, in this 1948 photo. This was Dr. Humphrey's first day on the job as the academic dean at Shepherd College. Jean was the assistant registrar. They are standing in front of Knutti Hall, which held administrative offices, a library on the first floor, and classrooms upstairs. (Courtesy of Jan Shipley Roth, Fallston, Maryland.)

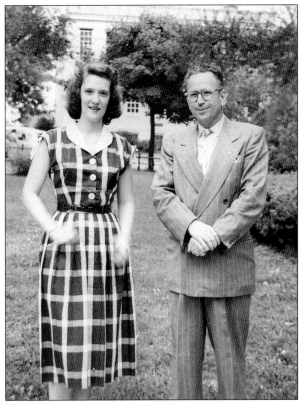

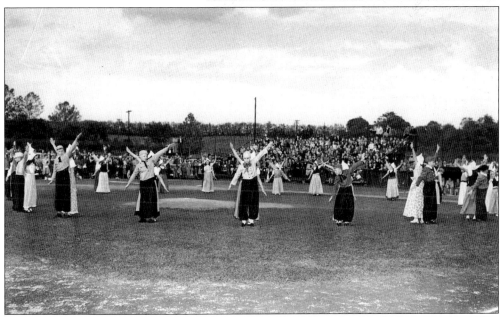

Here is a class from Shepherdstown Elementary School doing a Dutch dance in the 1950s. While the costumes look fairly authentic, it does not look as if they are wearing wooden shoes. Dancing in the wooden shoes would have been very difficult. (Courtesy of Scarborough Library collection, Shepherd University.)

This 1952 photograph shows a group of children who were enrolled in the pre-school at Shepherd College. Jan Shipley Roth is the little girl in the dark coat on the right. Others are unidentified. (Courtesy of Jan Shipley Roth, Fallston, Maryland.)

Shepherdstown Graded School closed its doors after the 1956–1957 school year. The school was located on the northwest corner of High and King Streets. Members of the teaching staff, from left to right, are principal Freel G. Welshans, Mary D. Reinhart, Eugenia Lowe, Mary Emma Conard, Katherine T. Rexrode, Georgina McKee, Virginia Hawn (in front), ? Pennell (in back), Mildred Strider, and unidentified. (Courtesy of Jefferson Security Bank, Shepherdstown.)

Four

TRANSPORTATION

If any form of transportation is identified with Shepherdstown, it is the steamboat, which was created by James Rumsey. That invention put the little town on the map and kept it there since the 18th century. Having been encouraged by George Washington himself, James Rumsey perfected the invention, and Shepherdstown's place in history was reserved forever, even if Fulton did get most of the credit.

Of course, the town's early forms of transportation included horses and buggies, and many photographs will show that. A few especially interesting horse-and-buggy photographs are on page 90 and on page 52. All those horses, ponies, and mules needed to pull all those buggies must have created quite a bit of fertilizer (which needed to be cleaned up). Fortunately for those animals, the Town Run was available for watering them on a hot day.

In early days, the only way to cross the river would be on a ferry or at one of the several fords. Eventually, bridges would be built. In fact, over the years, many bridges would be built and would have to be rebuilt when floods destroyed them, time and again. There would be covered bridges for wagons and later cars. There would be railroad bridges for the trains. There would be toll bridges, which would require payment in order to use them. Fortunately for the state of West Virginia, all of the bridges would be owned by either the railroads or the state of Maryland so maintenance would not be required of West Virginia.

Fortunately for Shepherdstown, the location of the town on the Potomac River helped guarantee that it would be easy to get goods and people to the town to encourage its growth and prosperity. And today it does just that—it prospers, although the residents like to control the growth.

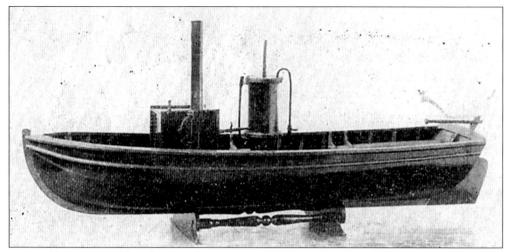

Pictured here is a model of the steamboat designed and owned by James Rumsey. He successfully demonstrated his steamboat on the Potomac River in September 1786. The 48-foot, flat-bottomed boat was launched from the ferry landing off Princess Street. Rumsey operated the steam engine, and his brother-in-law, Capt. Charles Morrow, was at the helm as they traveled a quarter of a mile upstream at the speed of approximately three knots. The crowd of spectators that witnessed this historic feat went wild with cheering. Robert Fulton demonstrated his steamboat in 1803, 16 years later—ironically, he was given credit for the invention. (Courtesy of Jim Surkamp, Shepherdstown.)

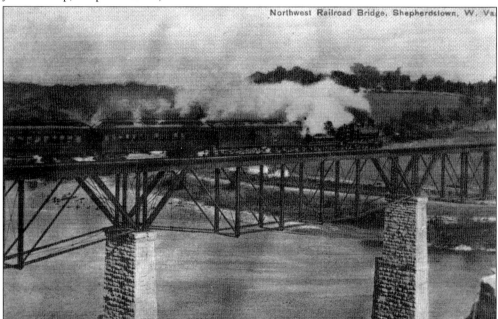

A steam engine crosses the Northwest Railroad Bridge at Shepherdstown, the first railroad bridge, which was built in 1880. A passenger train is shown heading into Maryland, possibly on its way to Sharpsburg or beyond. The steam locomotive was invented by Richard Trevithick of England in 1804. In the United States, John Stevens was the first man to build a steam locomotive. The first steam locomotive placed in regular service in the United States was in 1839. (Courtesy of Jefferson County Museum, Charles Town.)

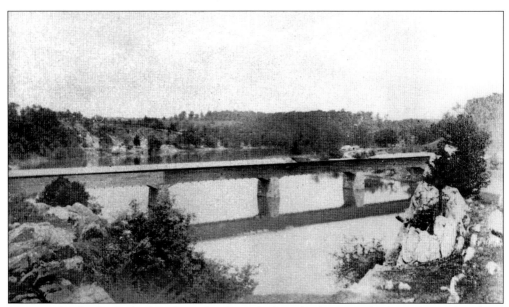

This wooden bridge had a shingle roof and weatherboard sides. It was built in 1871 and replaced the original bridge, which had been built in 1850 and was burned by Confederate soldiers in 1861. In 1889, the pictured bridge was destroyed by a flood. (Courtesy of Jefferson Security Bank, Shepherdstown.)

Originally built in 1849, only the supports of this covered bridge still stand. Two weeks after the Battle of Antietam in October 1862, Alexander Gardner took this photograph while he was working for Matthew Brady. The photograph is looking south toward Shepherdstown from a hillside in Maryland. The bridge was burned by Stonewall Jackson. (Courtesy of Jim Surkamp, Shepherdstown.)

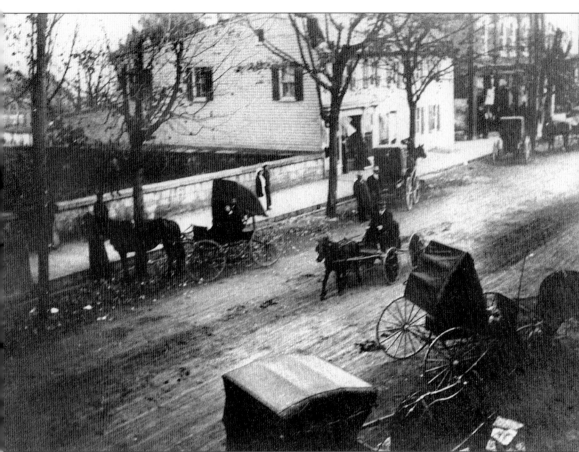

Pictured here are many horses and buggies, as well as a pony pulling a cart in the middle of German Street. Horses and buggies were the primary mode of transportation. (Courtesy of Jefferson Security Bank, Shepherdstown.)

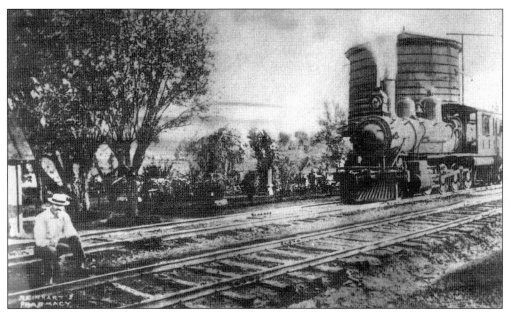

Pictured here is the water tank at Shepherdstown. Seated on the tracks is Charles McDonald, who was a tender. This is a photograph of an earlier freight train station from 1905. Because the train engine relied on steam for power, engineers had to periodically stop to take on water and fuel. Early locomotives weighed as much as six short tons and could pull only a few light cars. Today's locomotives are much larger, weighing as much as 700 short tons, and can pull as many as 200 loaded freight cars. (Courtesy of Jefferson County Museum, Charles Town.)

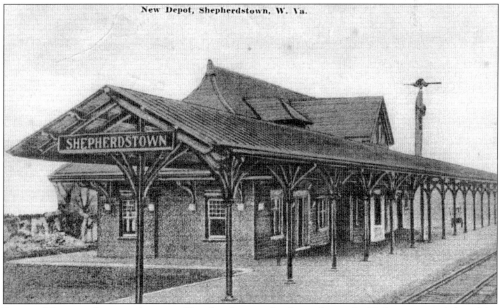

Pictured here is the new depot at Shepherdstown, built in the early 20th century. A bond by male taxpayers to finance a new railroad was approved by a vote of 626 to 388 on March 31, 1870. On April 2, 1872, the bond was authorized, and the railroad became known as the Shenandoah Valley Railroad, later to be called the Norfolk and Western (N&W) system. This depot would come much later. (Courtesy of Jim Surkamp, Shepherdstown.)

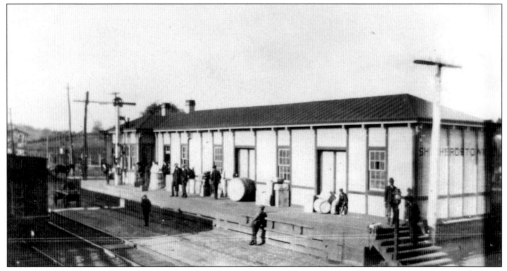

Pictured here is the Shepherdstown freight station. Without the railroads, freight in this county would have been at a standstill. In fact, railroad tracks have carried more than freight. The N&W Railway train took 24 minutes to go from Hagerstown to Shepherdstown, carrying fire equipment to assist the town's bucket brigade. Shepherdstown was, in fact, once a central shopping point. Wagoners came from Baltimore and brought salted fish, cheese, pickles, sugar, and hard candy. There were 30 or more businesses in the area to which salesmen catered. (Courtesy of Margie Redding Blostine, Shepherdstown.)

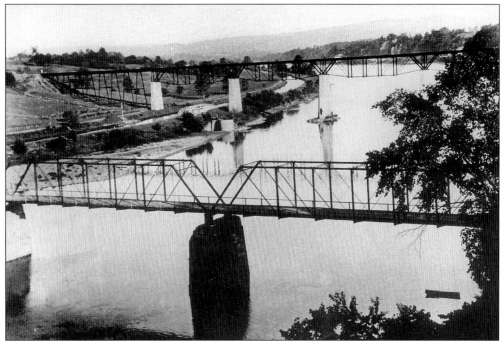

Pictured here are several modes of transportation. In the distance is the Shenandoah Valley Railroad Bridge. In the foreground is the old car bridge, and on the left is the C&O Canal river lock, which goes to Shepherdstown. Of course, the body of water is the Potomac River. (Courtesy of Jefferson Security Bank, Shepherdstown.)

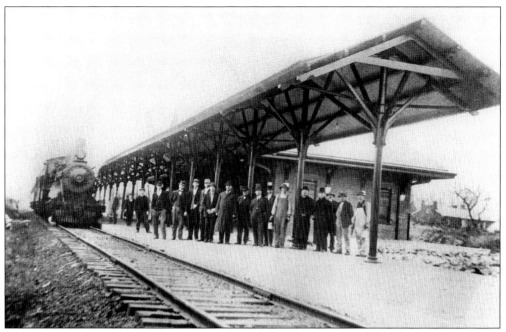

Many gentlemen stand under the covering of the N&W Passenger Station in Shepherdstown. The railroad came to Shepherdstown in 1880. (Courtesy of Jefferson Security Bank, Shepherdstown.)

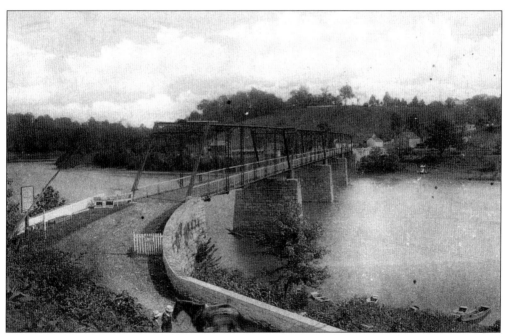

This bridge was a toll bridge. Two men seem to be considering whether they should cross or not. On the right of the photograph can be seen wooden boats and flat-bottom boats, which belonged to local residents. In the 1960s, the practice of leaving your boat tied along the river bank was discontinued. (Courtesy of Jefferson Security Bank, Shepherdstown.)

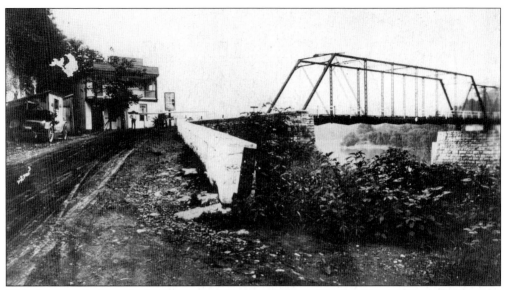

This photograph shows the bridge over the Potomac River at Shepherdstown. Many photographs have been taken of this and other bridges over the years. In the 21st century, a new bridge was built to replace a bridge that had been constructed in the 20th century. (Courtesy of Jefferson Security Bank, Shepherdstown.)

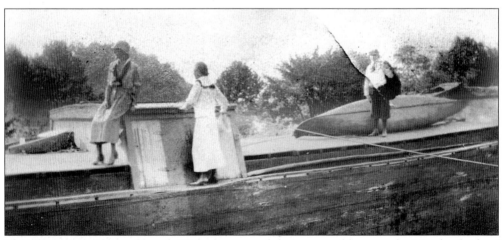

This photograph is from the early 20th century and shows a canal boat on the Maryland side of the Potomac River with members of Shepherdstown's Waddy family pictured. The canals were put in place to improve the river system in America. In fact, the Potomac Company wanted to develop the Potomac River as the great gateway to the West. (Courtesy of Jim Surkamp, Shepherdstown.)

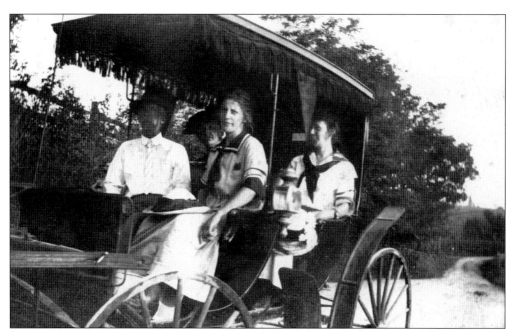

The fringe on this surrey goes all the way around the roof to add a bit of class. The surreys that looked like automobiles were referred to as "automobile seat surreys." Two-seated surrey prices varied from $51.95 to $104.95 for a very elaborate version. (Courtesy of Jim Surkamp, Shepherdstown.)

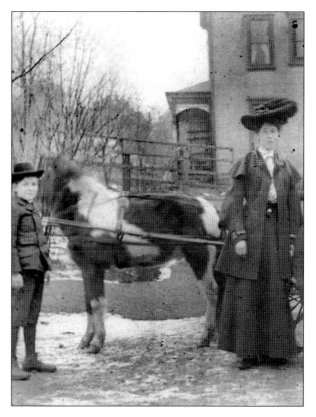

A very fashionably dressed lady stands beside her horse-and-buggy in front of a large home in Shepherdstown. A young man stands in front of the pony, holding its halter. Notice the traveling overcoat with matching hat and skirt. There appears to be some snow on the ground, which means this photograph was taken in the winter months. The year is unknown. (Courtesy of Jim Surkamp, Shepherdstown.)

These two young girls await their driver as they sit on the front bench seat and stand in the back of a primitive pick-up truck, which had headlights but no windshield. A partial license plate can be seen on the front. Truck registrations have consistently increased over the years: in 1904, there were 700; in 1905, there were 1,400; in 1910, there were 10,123; and in 1915, there were 158,506. (Courtesy of Jim Surkamp, Shepherdstown.)

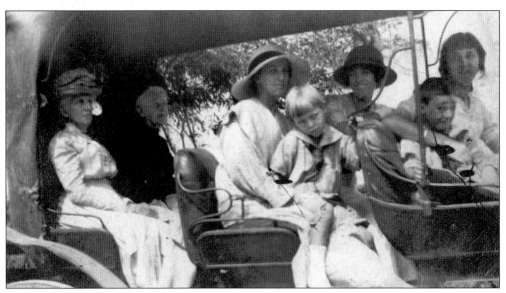

Pictured here are six Shepherdstown women and two children ready to take a pleasure drive. Notice the hats on the ladies. This is probably a wagon pulled by one or more horses. The young man in the front seat seems to be particularly happy to be included in the outing, whereas the child in the second seat seems a bit apprehensive. (Courtesy of Jim Surkamp, Shepherdstown.)

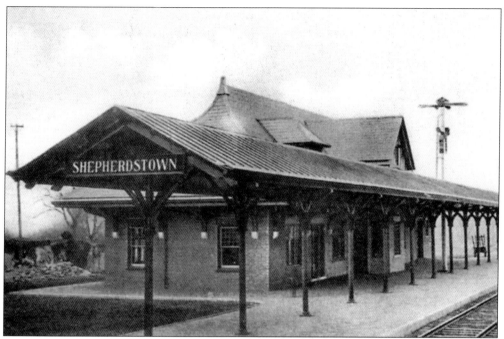

The N&W Railroad Station was constructed in 1909 and served the community for many years for both freight and passenger service. (Courtesy of Jefferson Community Bank, Shepherdstown.)

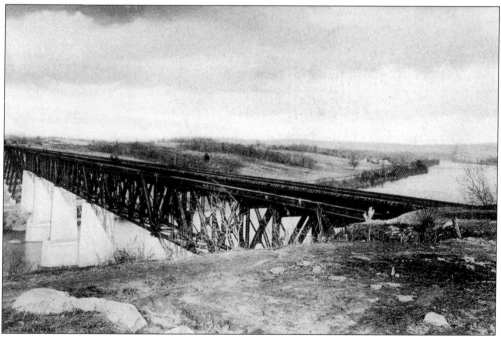

The Potomac River is visible in this 1910 photograph, which also shows the new N&W Railroad Bridge. (Courtesy of Jefferson Security Bank, Shepherdstown.)

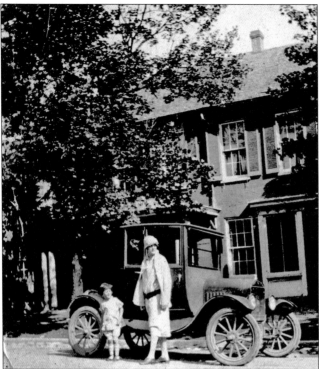

Though the names of the woman and child are not known, this photograph, probably taken in the early 20th century, is a wonderful example of transportation of the day. (Courtesy of Jim Surkamp, Shepherdstown.)

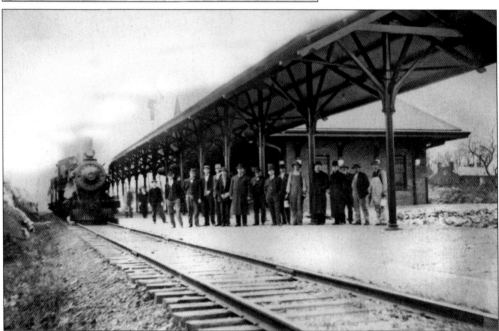

The present-day Shepherdstown train station is pictured here, shortly after it was completed in the early 20th century. Notice that all of the men are wearing hats. Hats were not just the fashion—they were required! They were considered so important that the 1908 Sears catalogue listed 58 different styles of hats, varying in price from a mere 23¢ for a gold-colored cap to a whopping $2.19 for a very dapper, black, stiff hat. (Courtesy of Margie Redding Blostine, Shepherdstown.)

The view from this buggy is on Shepherd's Grade, approaching the Shepherd family's "Upper Farm." Later it would become the site of the National Conservation Training Center (NCTC). Prices of buggies varied widely. For example, in the 1908 Sears catalogue, the prices ranged from $25.95 for a simple buggy to $104.95 for a very elaborate surrey. (Courtesy of Jim Surkamp, Shepherdstown.)

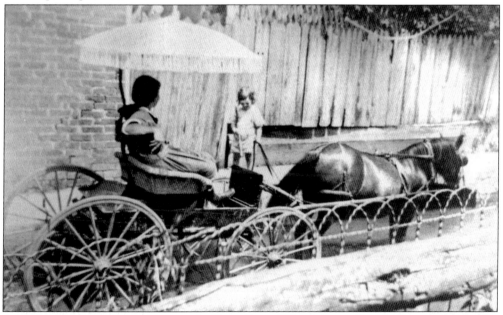

A mother waters her buggy horse in the Town Run off King Street. Her child is standing in the distance. This photograph dates to around 1910 and was taken behind the library. The Town Run provided water for many local residents and even enticed settlers to take up residence here. The run's true name was Falling Spring, because the falling water was the potential for power. Almost 25 springs are tributaries to the Town Run, and it makes a two-mile journey through Shepherdstown. (Courtesy of Jim Surkamp, Shepherdstown.)

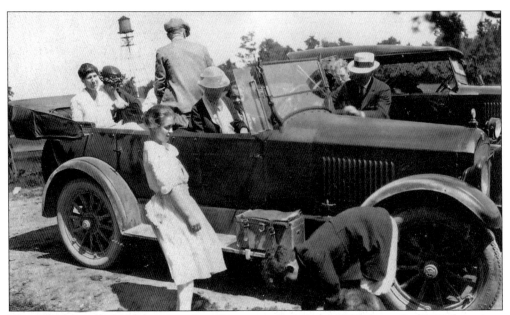

The Goldsborough family prepares for a "motor trip" in this c. 1915 photo. In 1900, there were only 8,000 automobile registrations in the United States. In 1915, the number of automobiles registered had risen to 2,332,426. That trend continued over the years, as more and more people purchased automobiles for family use. (Courtesy of Jim Surkamp, Shepherdstown.)

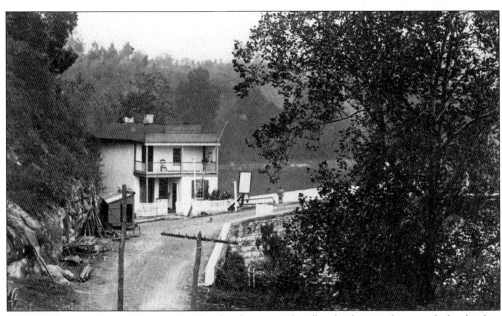

Pictured here is the toll house in Shepherdstown. The flood of 1936 destroyed the bridge. (Courtesy of Jefferson Security Bank, Shepherdstown.)

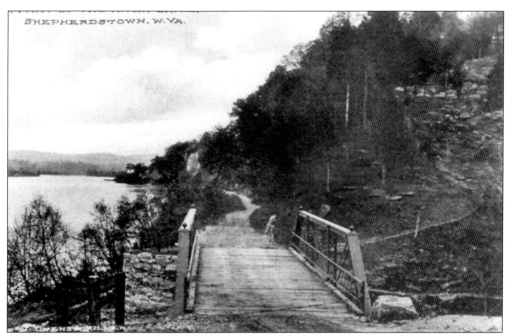

Teague's Run passes beneath this bridge. The bridge is located on River Road just east of Shepherdstown. Around 1960, the bridge was dismantled, and a culvert was installed. (Courtesy of Jefferson Community Bank, Shepherdstown.)

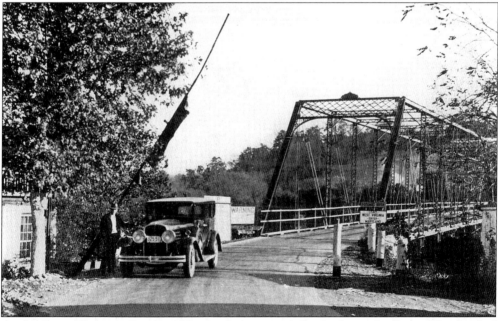

At the foot of Princess Street in Shepherdstown stood this bridge and tollgate. The flood of 1936 destroyed the bridge. The sign on the bridge says "Potomac River, Leaving West Virginia, enter Maryland." The line for the state of Maryland begins at the river's edge by West Virginia. Therefore, any repairs to the bridge were the responsibility of Maryland. (Courtesy of Jefferson Security Bank, Shepherdstown.)

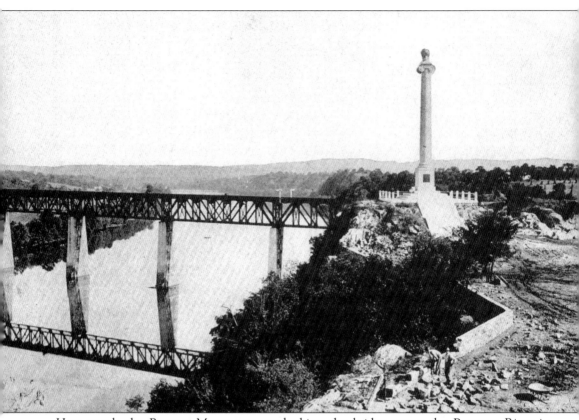

Here stands the Rumsey Monument overlooking the bridge across the Potomac River in Shepherdstown. The wall along the cliff edge where the railroad crosses the Potomac River was being constructed by stonemasons, seen standing in the foreground. (Courtesy of Jefferson Security Bank, Shepherdstown.)

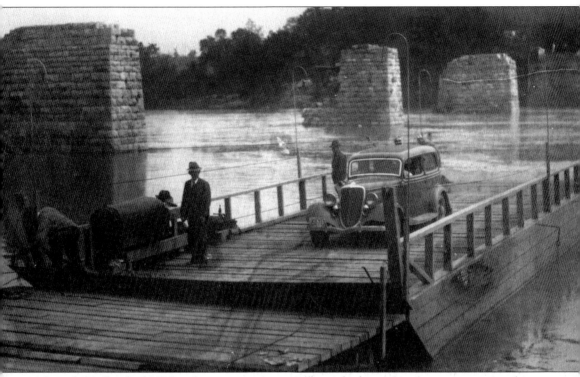

After of the flood of 1936, a ferry was in use to allow vehicles and pedestrians to cross the Potomac River. Here, one car is being ferried across, along with several people. Ferries traditionally charged a fee for the vehicles and often a fee for each vehicle passenger in addition to a fee for regular pedestrians. (Courtesy of Jefferson Security Bank, Shepherdstown.)

Mr. Fred Sewell stands proudly beside his car with his foot resting on the running board. Running boards were popular at this time. Later they would go out of fashion and then come back again, as the styles of the vehicles evolved. This car appears to be from the 1930s or 1940s. (Courtesy of Richard Clark, Shepherdstown.)

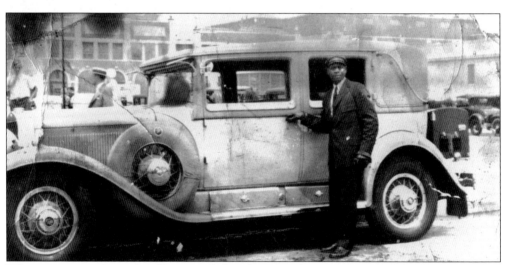

What appears to be a chauffeur stands beside a very large car, presumably waiting for his passengers. This car appears to date from the 1920s or very early 1930s. Following are statistics detailing the number of automobiles sold in this country in various years: in 1920 there were 1,905,560 sold; in 1925, there were 3,735,171 sold; by 1929, this number had increased to 4,455,178; and in 1930 (after the stock market crash of 1929), the number had decreased to 2,787,456. History proves that auto sales are tied to the economy. (Courtesy of Jim Surkamp, Shepherdstown.)

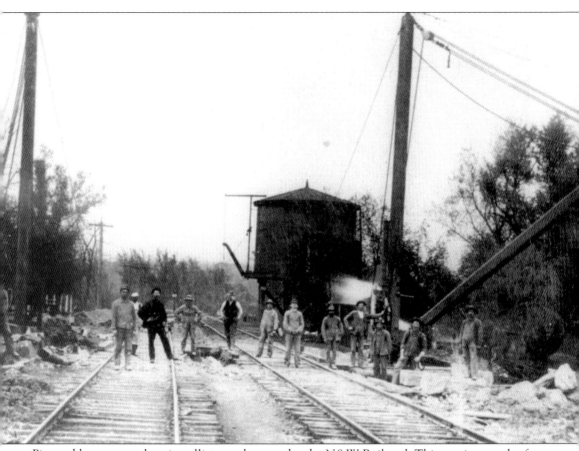

Pictured here are workers installing a culvert under the N&W Railroad. This was just south of Shepherdstown. (Courtesy of Jefferson Security Bank, Shepherdstown.)

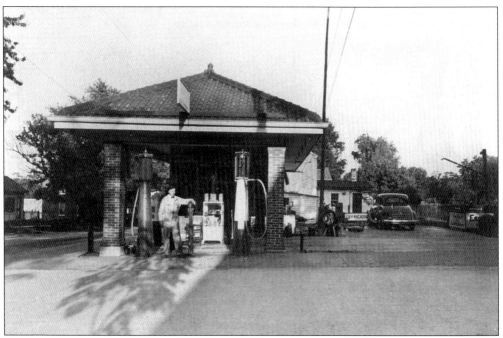

Pictured here is Judy Rogers's filling station. This photograph was taken in the late 1930s. The station was located on the southeast corner of High and Princess Streets. (Courtesy of Jefferson County Bank, Shepherdstown.)

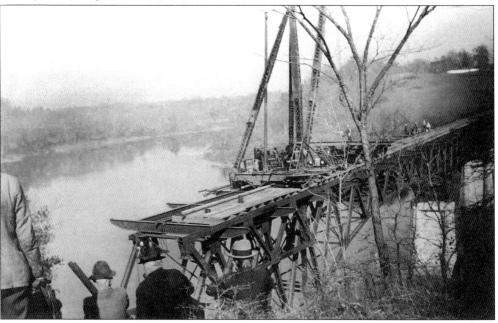

This photograph shows the Rumsey Bridge as it nears completion. Maryland and West Virginia negotiated, and the James Rumsey Memorial Bridge was constructed with its dedication taking place on July 15, 1939. It was only proper and fitting that the bridge would be dedicated to James Rumsey, for it was he who put Shepherdstown on the map when he invented the steamboat. (Courtesy of Mary Horky, Shepherdstown.)

Five

FASHION

Shepherdstown has always displayed a sense of fashion that was a cut above surrounding communities, as evidenced by the photographs in this chapter. Today the town is sometimes referred to as "Georgetown West," both for its fashion sense and its intellectual atmosphere.

Many of the outfits featured here were made at home. Today the mother who sews for her family is somewhat of a novelty; years ago, the mother who *didn't* sew for her family was a novelty. Many women looked at the catalogs or magazines to get ideas for their dresses and then would order fabrics and make their own dresses. Often, women also made their husbands' suits.

The men, women, and children of yesteryear dressed more formally than we do today. For young men, the transition from knickers (short pants, or knickerbockers, as they were originally called) to long pants was a rite of passage, as was the change from knee-length dresses to full-length dresses for young ladies. Babies, whether boys or girls, often wore only dresses their first year. Clothing fabrics included wool for men's suits, which was warm in the winter and very uncomfortable in the summer. Women's dresses covered camisoles and petticoats, and for a time, bustles, which made for a warm ensemble. The hats that both sexes wore were both stylish and warm.

As with other chapters, photographs have been arranged chronologically when possible.

Two very well-dressed children pose for this photograph. The young man is wearing a suit with knickers, short for knickerbockers, long socks or leggings, and leather shoes. He also sports a large bowtie and a hat. The young lady looks lovely in her Sunday best, including a bow in the hair and a bow at the neckline. Her shoes appear to be white leather. This photograph was taken during the horse-and-buggy days as evidenced by the wagon behind the children. (Courtesy of Jim Surkamp, Shepherdstown.)

This group of women, girls, and young boys appears to be all decked out for traveling in this *c.* 1900 photograph. Notice the long coats and the broad-brimmed hats. They stand in front of a large home in town. Notice the third person from the left—she is carrying what appears to a valise. The boy on the left appears to be wearing a suit with knickers, and the boy on the right seems to be more casually dressed. (Courtesy of Jim Surkamp, Shepherdstown.)

This young lady appears to be wearing her Sunday best dress, along with her white shoes and her knee socks. Since the rule of fashion has been to not wear white shoes before Memorial Day or after Labor Day, maybe this photograph was taken during the summer. She has what appears to be large bow in her hair and is holding a baby, probably because it is too young to walk (notice it is not wearing shoes). (Courtesy of Jim Surkamp, Shepherdstown.)

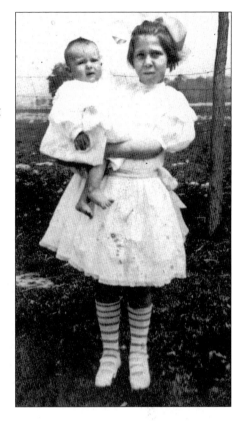

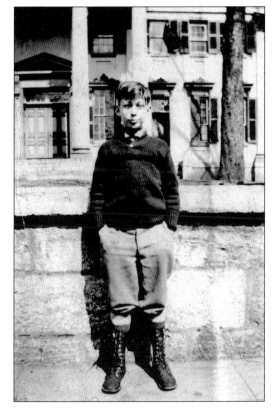

Though this young man is unidentified, it is known that he is standing in front of McMurran Hall and that the photograph dates from the early 20th century. The wall against which he stands was created by Gregory Britner of Shepherdstown. (Courtesy of Margie Redding Blostine, great-great-granddaughter of Gregory Britner.)

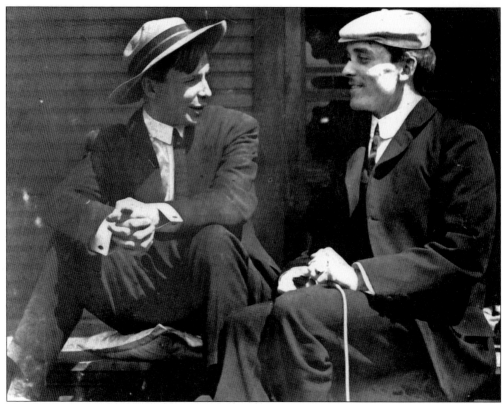

The left gentleman is not identified, but the gentleman on the right is Carl Wilhelm Littler. Carl was in the steel business, where he was known as a touch businessman, having been associated with Jones and Laughlin Steel in Pittsburgh. (Courtesy of Margie Redding Blostine, Shepherdstown.)

These attractive ladies make a fashion statement with their hats and their suits. An overcoat or blanket is located on the rocks behind the women, in case the temperatures dropped more. The photograph was taken at the Rumsey Monument, with the river in the background. The year of this photograph is unknown. On the left is Hortense "Ducy" Britner. The lady on the right is unidentified. (Courtesy of Margie Redding Blostine, Shepherdstown.)

The man in the center in the back, wearing the bowler, is Carl Littler. The lady on the left in the white dress is Hannah, and the lady on the right is Margie Britner Littler, Carl's wife, at the age of 18 or 20. The African American lady with the stylish hat and dark bow at the neck is unidentified. (Courtesy of Margie Redding Blostine, Shepherdstown.)

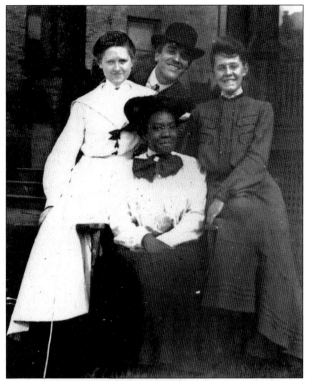

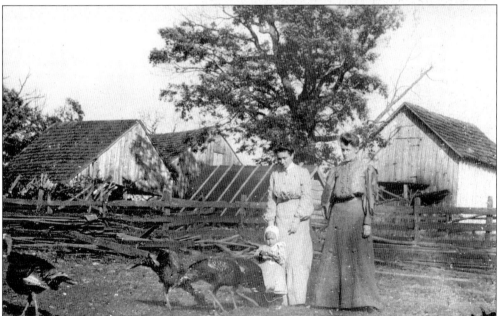

Pictured on a farm outside of Shepherdstown is "Min" on the left, who was married to Margie Britner's uncle. Margie is on the right. Petticoats, such as these ladies wore, were worn daily, and could be heavy and uncomfortable on a hot and humid summer afternoon. The two ladies stand with a small child and several turkeys. The photograph dates from 1904. (Courtesy of Margie Redding Blostine, Shepherdstown.)

Handsome young Richard Britner poses in his double-breasted overcoat. Richard was born in 1906 or 1907 and was a member of a prominent Shepherdstown family. Notice the leggings and the high-button shoes. It would take quite some time to button all those buttons! (Courtesy of Margie Redding Blostine, Shepherdstown.)

Grandpa John Henry Show appears in this photograph in his Sunday best. One of his cousins even referred to him as "the Kentucky Colonel." Notice the bow tie, very stylish for the times. And the three-piece suit was all the rage. He looks refined and handsome with his neatly manicured beard and mustache, while sitting in an elaborately hand-carved chair. There is a piano in the Entler Hotel that belonged to his wife, on which rests a photograph of him. (Courtesy of Margie Redding Blostine, Shepherdstown.)

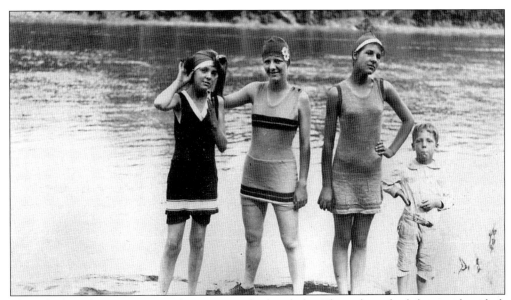

These bathing beauties seem to be enjoying the limelight. The girl on the left is unidentified, but the girl in the middle is Helen Goldsborough, and the girl on the right is Sickie Billmyer. The small boy to her right is the brother of Helen. This photograph was taken in the early 20th century on the Potomac River at Flat Rock, where locals would enjoy a cool dip on a hot afternoon. (Courtesy of Jim Surkamp, Shepherdstown.)

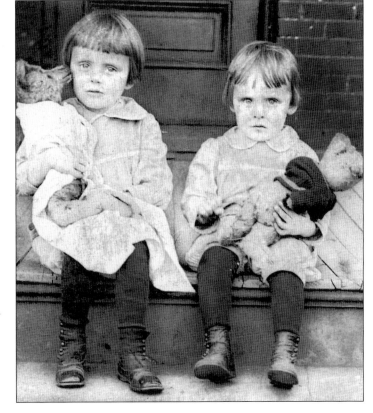

Two darling little girls take a break from their busy play day by sitting on the stoop and comforting their teddy bears. On the left is Deda, at about three and four years of age, and on the right is her sister, Charlotte, around 18 months to two years of age. Notice the leggings and the high button shoes—there were in style for the times, c. 1909. (Courtesy of Margie Redding Blostine, Shepherdstown.)

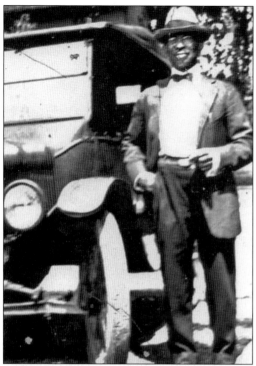

Mr. Fletcher Hopewell stands beside what appears to be a Model A Ford in the 1920s. Mr. Hopewell is wearing a two-piece, single-breasted suit jacket with matching slacks, a bow tie, and a hat, making a fashion statement to be sure. (Courtesy of Richard Clark, Shepherdstown.)

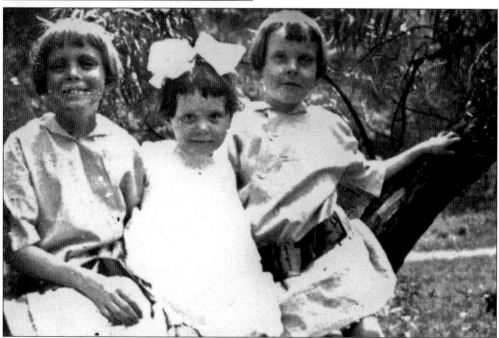

Sitting on a branch are three lovely ladies in this 1914 or 1915 photograph. On the left is Thelma Littler (nickname "Deda"), the middle girl is unidentified, and the girl on the right is Charlotte Littler. Deda was born around 1905, which makes her 9 or 10 in this photograph, and Charlotte was born in 1907, which makes her 7 or 8 here. (Courtesy of Margie Redding Blostine, Shepherdstown.)

Tea for one, anyone? Here sits a lovely miss waiting to serve a guest a spot of tea. Pictured here is Kathleen Alvin, daughter of Dr. Alvin. Note that her hair is cut in the very fashionable style of the day, a bob. (Courtesy of Margie Redding Blostine, Shepherdstown.)

In the 1920s, Dick Devonshire stands beside a convertible with a fashionably dressed woman. Though her flapper hat shows her style, Mr. Devonshire has probably placed his hat on the seat of the car. (Courtesy of Richard Clark, Shepherdstown.)

This beautiful little girl is wearing the ever-popular white oxford shoes, which used to have to be polished with white shoe polish after each wearing to keep them looking nice. The bonnet she wears matches her pinafore and completes her ensemble. (Courtesy of Jim Surkamp, Shepherdstown.)

This handsome young man seems to be dressed for a Sunday occasion. He looks so dapper in his white sports coat and dark dress slacks; he is even wearing his spectator shoes to complete his ensemble. (Courtesy of Jim Surkamp, Shepherdstown.)

These lovely ladies are posing in the 1920s in front of what later would become Betty's Restaurant. The lady on the left is unidentified, but the lady on the right is Reva Copenhaver White. The beads around the neck of the mystery lady add a dramatic touch to her ensemble. Reva looks refreshing in her light dress and shoes. (Courtesy of Jim Surkamp, Shepherdstown.)

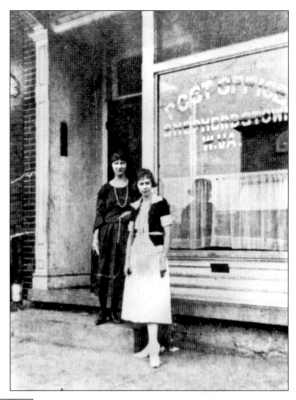

The name of this beautiful child is unknown, as is the date of the photograph, though it is assumed to date from the 1920s or 1930s. Sitting on the front steps of a Shepherdstown building, the little girl sports a bow in her hair and stylish leather shoes. Most likely, she was a member of the Robinson or Clark families. (Courtesy of Jim Surkamp, Shepherdstown.)

"Deda" Littler married Arthur Redding to become Thelma Littler Redding. Deda's mother was Margie Britner Littler. Born and raised in Shepherdstown, Deda had two children, both daughters, one of which passed away as an infant. Their surviving daughter is Margie Redding Blostine of Shepherdstown. (Courtesy of Margie Redding Blostine, Shepherdstown.)

Here Delores Christian poses in her warm winter coat with a fur collar. Fur collars, boas, and even fur coats were very fashionable and popular in the first half of the 20th century. This coat is obviously a dress coat, as opposed to a more casual coat that people wear today. Notice the tailored look with a cinched and belted waist. (Courtesy of Richard Clark, Shepherdstown.)

Thelma Littler Redding poses in her sporting ensemble, which might be a bathing suit and cap. (Courtesy of Margie Redding Blostine, Shepherdstown.)

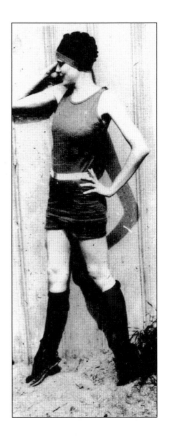

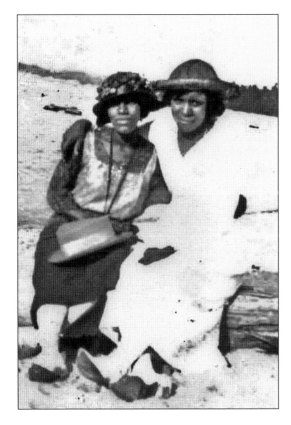

Probably taken in the 1930s, this picture features two ladies, probably members of the Clark or Robinson families, who repose on a log near the water's edge enjoying the pleasant day. The lady on the left appears to be holding a hat, which may have belonged to the photographer. (Courtesy of Jim Surkamp, Shepherdstown.)

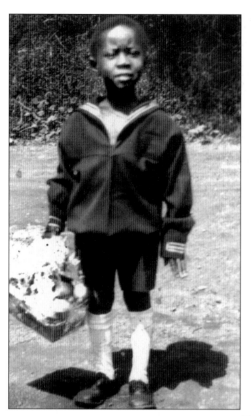

Little Bill Grantham is all ready to reap the rewards of Easter as he stands with his basket in his right hand in this early 1930s photograph. Notice the knickers and the sailor theme for Bill's ensemble. This Easter was a pleasant day, sunny and fairly warm, based on what Bill is wearing. (Courtesy of Jim Surkamp, Shepherdstown.)

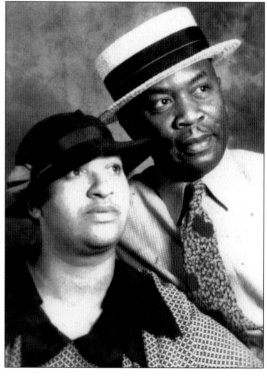

In this 1930s photograph are pictured Mr. Washington Drew and his wife, Pauline Nickerson Drew. The hats they are wearing reflect the cultural style in the 1930s. Even if men went to a baseball game, they were expected to wear a suit jacket or sports coat, a tie, and a hat. Ladies wore hats also, and that fashion continued for many years. (Courtesy of Jim Surkamp, Shepherdstown.)

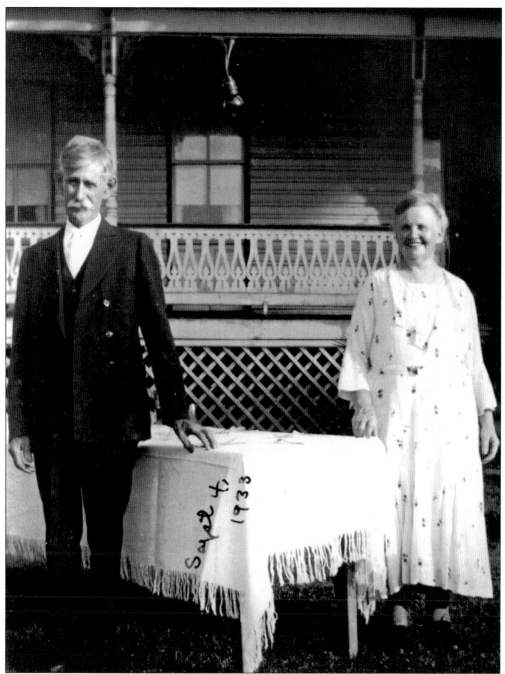

Pictured here are Mr. and Mrs. William J. Britner. This was Mr. Britner's second wife, Martha Lee, who was a Flannegan from Bakerton. They are pictured in front of their home, which stayed in the Britner family for about 100 years. The house was located on Route 480 near Lowe Drive, across from the Clarion Inn. In this image taken September 4, 1933, Mr. Britner is wearing a double-breasted suit with a vest, a white shirt, and a white tie. Mrs. Britner looks lovely in her patterned dress with a white background and three-quarter length sleeves. Her hair is done in the style of the day for older women. (Courtesy of Margie Redding Blostine, Shepherdstown.)

Beautiful gowns are worn by these high school students at their prom in 1965. From left to right are (first row) Lynda Mills, Nancy Seiders, Elain Weller, Laura Shuler, Nancy Burnett, Diane Knott, Jan Shipley, prom queen Frances Gottschalk, Mary Ellen Constant, Janice Weller, Aleta Lehew, Susan Stanley, Ann Myers, and Vickie Breeden; (second row) Jimmy Keller, Rusty Miller, Brad Waldeck, Cheri Carter, Linda Vaughn, Shirley Kidwiler, Douglas Currier, Charles Creamer,

and Paul Potter; (third row) Jimmy Knode, Steve Weller, Jimmy Rentch, Steve Handzo, Charles Kidrick, Marvin Woodfork, prom king Ben Miller, Tony Thomas, George Washington, Bobby Housden, Calwin Wittington, Danny Markham, Lynn Graves, and Phillip Stickley. (Courtesy of Jan Shipley Roth, Diana Knott, and Peggy Currier Talley.)

This unidentified lady has a flair for fashion, as evidenced by her floppy brimmed hat and her beautifully adorned sweater. The time frame during which both men and women wore hats daily was from the 1920s to the 1940s. (Courtesy of Richard Clark, Shepherdstown.)

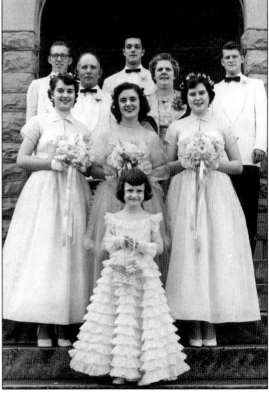

Taken in front of St. Peter's Lutheran Church, this photograph is of Lena Swope's wedding. Serving as flower girl is Jan Shipley, center. The maid of honor, Isabel, is positioned in the center of the group. The bride and groom are not photographed here, only the wedding party. (Courtesy of Jan Shipley Roth, Fallston, Maryland.)

Six

TODAY

Shepherdstown residents have been conscientious in preserving their past, and so many buildings today appear much as they did when they were built. Many have been well maintained over the years, and others have been restored. Shepherdstown's most well-known buildings are featured in a walking tour. Visitors should make their first stop at the visitor center on German Street to pick up a brochure of the walking tour. The tour has been designed so that visitors see the sites pretty much in order to avoid wasted steps, which can be welcome on a hot, humid, sunny summer afternoon.

"Musts" to be seen include the following: Shepherdstown Museum, Entler Hotel, Rumsey Steamboat Museum, Mecklenburg Inn, McMurran Hall, War Memorial Building, Moulder Hall, Sheetz Building, Yeasley House, Conrad Shindler House, Trinity Episcopal Church, Presbyterian Manse, Episcopal Cemetery, Michael Rickard House, Baker House, St. Agnes Roman Catholic Church, Shepherdstown Presbyterian Church, Hodges Building, Yellow Brick Bank, Shepherd University Campus, The Little House, and the Town Run.

A leisurely stroll down German Street takes one back to times gone by, when things were more simple, which is how the residents of Shepherdstown strive to keep it. The visitor should stop in the unique shops that line German Street and chat with the friendly, outgoing shop owners. Many of the shops still display the "Peace" sign pictured on page four of this book.

The university provides the town with cultural performances and sporting events for every taste almost year-round. The library is open all year long and welcomes all patrons, whether they are students or not.

A stroll down side streets reveals well-maintained homes with nicely manicured lawns. If one didn't know the year, it would be hard to tell, as the houses and streets have remained much unchanged. Hopefully, the town will be able to remain so.

The Shepherdstown Library, still in use today, stands proudly on its original location and flourishes with activity from local patrons. Pictured in front of the library from left to right are Ray and Linda Weaver from Indiana, Pennsylvania, and Walt Wojcik from Harpers Ferry, West Virginia. (Photograph by Dolly Nasby.)

McMurran Hall is pictured here. Today it is used for offices and not for classes. Pictured on the porch between the pillars are Monica Lingenfelter (on the left) and Robin Zanotti. Ms. Lingenfelter is the executive vice president of the Shepherd University Foundation, and Ms. Zanotti is the vice president of advancement of Shepherd University. (Photograph by Dolly Nasby.)

The Entler stands majestically, as it has for decades. Situated on the corner of Princess and German Streets, it has a commanding view of the busy downtown and is still in use today, although not as a hotel. Standing in front are Shepherdstown residents Sam Byrne on the left and Kimberly Bowen on the right. (Photograph by Dolly Nasby.)

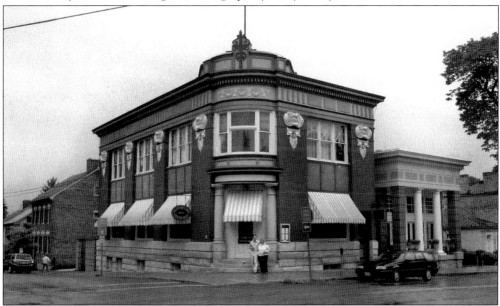

The Yellow Brick Bank looks very much the same as in years past. The name is a little confusing, because it is not actually constructed of yellow bricks, but rather features red bricks and yellow trim. Standing in front of the bank are Sam Byrne on the left and Kimberly Bowen on the right, both from Shepherdstown. (Photograph by Dolly Nasby.)

The Little House still stands proudly on Princess Street, just down from German Street. It is open periodically and closes for restoration from time to time. It has been well maintained over the years. It was established during the 1950s for the education department of Shepherd College. (Photograph by Dolly Nasby.)

The Town Run continues to run, although it is no longer used as a source of power. It runs through, under, and around, is sometimes visible and sometimes not, and it empties into the Potomac River, as it always has. One can imagine what Thomas Shepherd dreamed when he founded the first mill. There was no way that Shepherd, or any of the people who settled here and used the Town Run for power, could envision what a great little town would develop here. If they could only see it now! (Photograph by Dolly Nasby.)